POSTCARD HISTORY SERIES

Grand Rapids

IN VINTAGE POSTCARDS

1890–1940

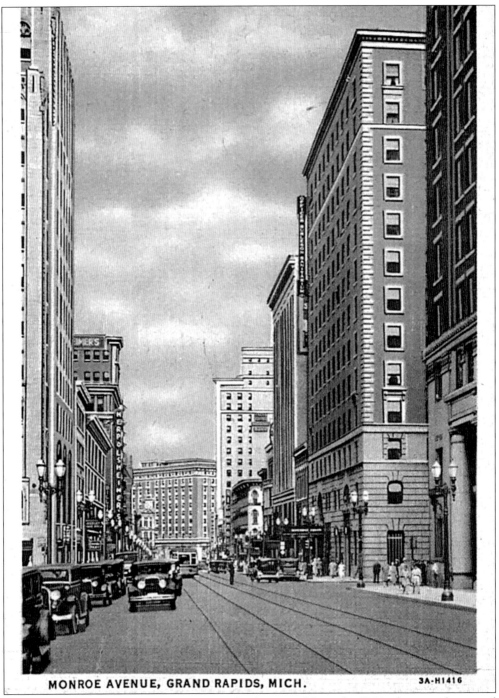

MONROE AVENUE, GRAND RAPIDS, MICH. 3A-H1416

Looking northwest toward Campau Square, this linen card from the 1930s shows a vibrant and active Monroe Avenue in downtown Grand Rapids. On the right is the People's Building; the new Morton House Hotel, built in 1923, and the McKay Tower (then G.R. National Bank) stand in the distance. On the left is the Grand Rapids Trust Company, later known as the Michigan National Bank Building.

POSTCARD HISTORY SERIES

Grand Rapids

IN VINTAGE POSTCARDS

1890–1940

Thomas R. Dilley

ARCADIA

Published by Arcadia Publishing
Charleston SC, Chicago IL, Portsmouth NH, San Francisco CA

Printed in the United States of America

Library of Congress Catalog Card Number: 2005925684

For all general information contact Arcadia Publishing at:
Telephone 843-853-2070
Fax 843-853-0044
E-mail sales@arcadiapublishing.com
For customer service and orders:
Toll-Free 1-888-313-2665

Visit us on the Internet at http://www.arcadiapublishing.com

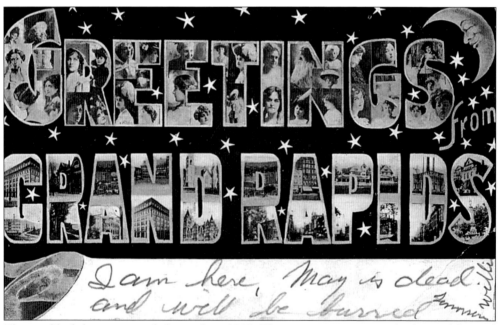

This is a block-letter postcard, dating from 1908. The message, written on the front of the card only, has a curious content: "I am here. May is dead and will be buried tomorrow." The card illustrates the widespread—if quirky—use of the postcard as a cheap, easy, and reliable means of communication.

CONTENTS

INTRODUCTION

What was to become the City of Grand Rapids, Michigan, began in 1826 as a crude log cabin—a frontier trading post—built and operated by Louis Campau, a Frenchman from the Detroit area. The post was constructed on the eastern bank of the Grand River at a group of rapids called by the local natives O-wash-ta-nong. From those simple beginnings a city, now home and workplace for hundreds of thousands, grew and prospered.

The early history of the city differs little from the growth and progress of other Midwestern settlements. As immigrants from across the Atlantic, or from the eastern seaboard, arrived and settled, they brought with them a diversity of skills, customs, and culture. The future of the little village was by no means certain at its founding, as demonstrated by the failure of countless other outposts in the unexplored Northwest. Things took hold here as the result of the tenacity and drive of early settlers, many of whom were the initial explorers of the region. Others arrived looking for a fresh start after failures in the "civilized" East. What these early settlers found on the banks of the Grand was a river to provide a ready and constant source of power and transportation. There were abundant natural resources, all of which could be, and ultimately were, exploited for the benefit of the settlers and that of a gradually growing community. Over the decades, following the establishment of Uncle Louis' trading post, the land on both sides of the river was cleared and platted to accommodate a village. Later, a town emerged, and then a city of increasing importance and sophistication.

In addition to serving as a gateway to the settlement of western and northern Michigan, the town, located at the edge of great pine and hardwood forests, nourished a fledgling cottage industry in the manufacture of furniture. At first, it prospered on a craftsman basis, but gradually grew into large-scale manufacturing. By 1920, the furniture industry in Grand Rapids employed thousands of semi-skilled and highly skilled workers, and the city had become the preeminent furniture manufacturer and market in the world.

In the following decades, the intensive activity in furniture manufacture brought employment and prosperity to the city, and significantly influenced the physical shape which the city was to take. This included the construction of hotels to house visiting buyers and conventioneers. Dozens of buildings were also dedicated to the display of locally manufactured furniture during furniture markets, which were originally semi-annual, and eventually became nearly continuous. Beautiful public buildings—many of which are now gone—were constructed, as well as churches, theaters, and commercial districts, all befitting the growth, prosperity, and needs of the community. The same growth produced fortunes, large and small, which fostered the construction of homes and neighborhoods, and a vast array of cultural and community-oriented institutions and activities.

The furniture business continued to evolve and expand until around 1930, when the crushing effects of the Great Depression took a heavy toll on the local manufacturers. Many of the largest and formerly most successful companies either merged with local or outside concerns, or disappeared altogether.

Gradually, Grand Rapids shook off the shroud of the Great Depression, as economic conditions improved and the world returned to peace in the late 1940s. Now benefiting from a more diverse manufacturing base, the city restored its economic and social growth, and regained its position as the center of economic and cultural activity in Western Michigan—a process which continues to this day.

With few exceptions, the postcards reproduced in this book date from the period of 1893 to 1930. This period includes what is widely viewed as the "Golden Age of Postcards," when postcard views of every imaginable subject and location were published and sold by the hundreds of millions in this country. The 228 cards reproduced here are all from the author's own collection and are representative of the several thousand different cards of local scenes dating from this period.

A Note about Postcard History

The picture postcard, available today in nearly every corner of the world as a cheap and easy means of postal communication, has enjoyed an interesting and important history. The first "mailing cards" appeared in 1869 in Austria, where they were introduced as a "message sending" innovation, with very great success. These Austrian cards were soon followed by similar cards in Great Britain and other European countries, where they were used by all levels of society as a quick, cheap, and easy means of postal communication. These early postcards carried no picture or design and were used with a message on one side and the address and postage on the other. Initial concern about the non-confidential nature of the messages on postcards was expressed, but quickly overridden by the vast popularity and convenience of their use.

Postal mailing cards crossed the Atlantic in 1871, when they were first authorized by the Canadian Postal Service. The first cards used in the United States were issued in 1893 in the same format used in Europe (that is, without pictures) with a one-cent stamp preprinted on each card. As they had in Europe and Canada, these cards became an instantaneous success, partly because of the rapidly increasing efficiency and frequency of postal delivery. In many places, it was possible to drop a postcard into a mailbox in the morning and have it delivered locally the very same day. This was a great and welcome convenience in the days before the widespread availability of the telephone.

Up to this point, postcards bore little or no printing, aside from a postage stamp. There were no pictures. Any message written by the user was restricted to one side of the card, with the address and a stamp or pre-printed postage appearing on the other.

Beginning in 1898, the United States Post Office permitted the use of privately printed and sold postcards bearing a photograph or image on one side, again with the address and postage only on the reverse side. Little or no text could be written on the card, though some cards had a small space on the face of the card for a greeting; sometimes the user simply wrote a message over the picture itself.

In 1907, postal regulations were again relaxed, allowing the "divided back" configuration of the postal side of the card, featuring the address and postage on the right side, and the user's message on the left.

During the Golden Age of the postcard, the highest quality cards sold in the United States were printed in the famous lithography shops in Europe, particularly in Germany. Hundreds of millions of such cards, depicting every city, town, and village in the United States, some with comical but unintentional translation errors, were imported and sold for domestic use. Political developments brought the availability of these high-quality European postcards to an end at the opening of World War I, when German sources were lost and the war effort made importation difficult or impossible.

Not all postcards in use in the United States at that time were imported, however. Many cards, particularly of local scenes, were produced by local publishers who not only photographed and printed the cards, but retailed them as well. In Grand Rapids, many of the best local views dating from the first decades of the 20th century were produced by a handful of local companies including the Will Canaan Company, the Heyboer Company, and west-side photographer, Peter Oosse.

Shortly after the turn of the 20th century, another form of postcard began to appear, the "real-photo" card. These cards are actual photographs printed on a card stock, with a postcard format for mailing stamped on the reverse side. Some real-photo cards pre-date the turn of the century, and were produced by professional or semi-professional (sometimes itinerant) photographers. However, the real source of most of these cards was the introduction in 1903 of the Kodak folding pocket No. 3A camera. This device, produced by the Eastman Kodak Company, was specifically designed for taking postcard-sized photos, which were then processed onto real-photo cards.

The real-photo cards most commonly depict scenes of small towns (where a printed card would have little commercial market), and local events and occasions, for which the successful sale of the card required a faster turnaround than a printed card allowed. Some real-photo cards were quite personal in nature, depicting families or small-groups, not really intended for wide public distribution. Most of these cards were produced anonymously, generally in small numbers. This makes them both very interesting views of contemporary life, and also highly collectible today.

Postcards proved an effective a means of communication in the early decades of the twentieth century, at a time when telephones were expensive, not readily available, or simply non-existent—but it is clear that many of the postcards bought and mailed every year were exchanged between collectors. The postcard-collecting mania of the Golden Age found thousands of enthusiasts who maintained large collections, often held in elaborate albums to be displayed at home as a sign of family travel and sophistication.

After the end of World War I, the importation of European cards resumed, but was hobbled by import duties and the increasing preeminence of locally-produced cards. Many such domestically-produced cards were printed with a white border in an effort to save a bit of printing cost. Earlier postcards took the image to the edge of the card in a printing process known as a "bleed," in which the printed item must undergo yet another process of trimming the edges.

Beginning in the 1930s, another form of postcard, the "linen card," began to appear. Linen cards are printed on a cloth-textured paper card stock, often in bright, even garish, colors. It was on these linen cards that the ubiquitous "road-side attraction" views began to appear in response to the emergence of automobile travel, both before, and especially after, World War II. As the use of postcards as essential communication devices subsided during this period, their use as travel souvenirs and greetings skyrocketed, resulting in thousands of nostalgic views of cities and tourist destinations, as well as hotels, motels, and restaurants along the way.

In the 1950s, linen cards were gradually replaced by chromatic images, or "chrome" cards, bearing a high-quality photographic image. Later, they evolved to a slightly larger postcard size than was previously used. This form of postcard is common today, and continues to be used for mailing and collecting.

As historical documents, the importance of postcards in the social history of the United States cannot be overstated. The images on the cards from almost any era—but especially in the decades prior to World War I, before news reporting included photographs—have captured people and events which would otherwise have gone unrecorded and unpreserved. Views of buildings, streets, and neighborhoods which have long ago disappeared provide collectors and historians with reliable contemporaneous details of rural, small-town, and big-city life. Many of the illustrations in books and magazines of today which chronicle the history of this era are, in reality, reproductions of vintage postcards.

The precise dating of the postcard images reproduced in this book is sometimes problematic. This information is often provided, at least generally, by the mailing date of the card—assuming that the card was mailed contemporaneouslyl. Otherwise, this information has been gleaned from additional written or photographic sources. Each of these cards now provides us with a vivid, useful, and sometimes unique insight into life in Grand Rapids a hundred years ago.

From the time I was a boy growing up here, I have always been interested in the history and architecture of Grand Rapids. Finding and collecting these cards has been and remains an enjoyable quest for me. Each card has become an instant "old friend" for me, and I hope that this glimpse into the Grand Rapids of the past is as enjoyable for you as it has been for me to assemble and present to you.

—Thomas R. Dilley

One

THE CITY

The history and development of the City of Grand Rapids, Michigan, during the period between 1890 and 1940 is well documented by the hundreds of postcards published and sold during this period. Though there have been many changes in the downtown landscape since that time, more than enough of the "old city" remains to allow recognition of these images.

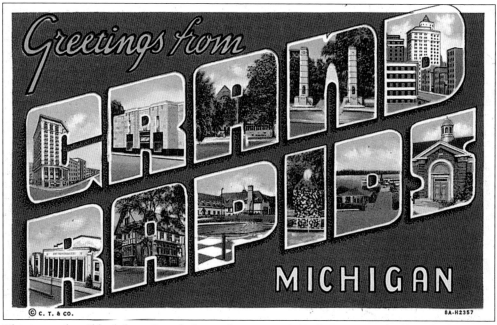

This is another "block letter" card, dating from around 1945. It is typical of hundreds of such cards produced by the Curt Teich Company of Chicago for towns and cities all over the United States. Each block letter contains a local scene.

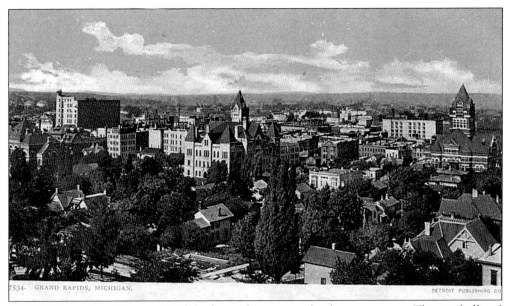

This 1900 view from Crescent Park looks southwest over the downtown area. The city hall and courthouse are visible at the center and right, respectively. On the left is the Michigan Trust Building, for many years the tallest building in Grand Rapids.

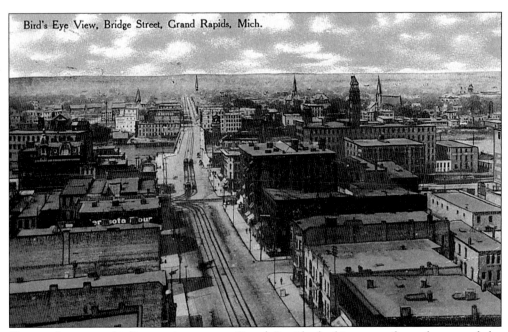

Shown above is a bird's-eye view across Grand Rapids, looking west from the top of the Michigan Street Hill, down Michigan Street to the river and beyond.

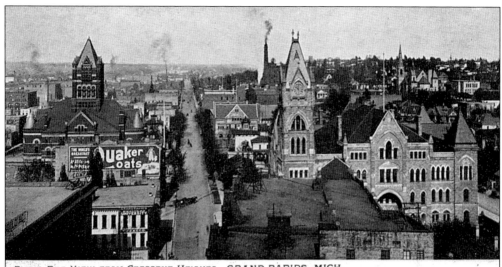

BIRD'S EYE VIEW FROM CRESCENT HEIGHTS. GRAND RAPIDS. MICH.

E. C. KROPP, PUBL., MILWAUKEE NO 808.

This view looks north, up Ottawa Avenue, from the roof of the Michigan Trust Building (not from "Crescent Heights," per the caption on the card), about 1898. Over the roof of the now demolished Houseman Building, the city hall, razed in 1970, is visible at the center. The Kent County Courthouse now sits on this site. At left stands the old Kent County Courthouse, also taken down in 1970; it is now the site of the City–County complex. In the distance is the chimney of the Grand Rapids Brewing Company.

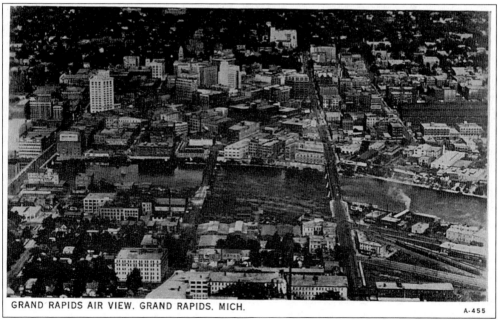

GRAND RAPIDS AIR VIEW. GRAND RAPIDS. MICH.

A-455

This 1930 card is a view from downtown Grand Rapids. The bridge at the right is Fulton Street, and at the left is Pearl Street.

11

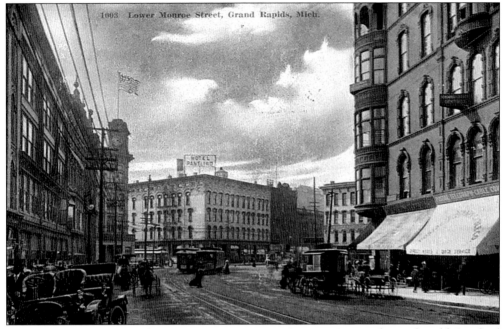

This c. 1908 artist's view down Monroe Avenue to Campau Square shows the old Pantlind Hotel at center. On the right stands the Wonderly Block, an office building occupied by a variety of professionals, including many dentists and lawyers.

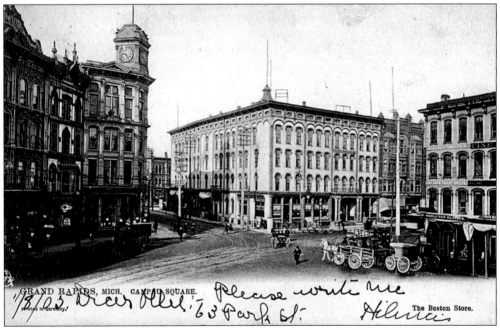

GRAND RAPIDS, MICH. CAMPAU SQUARE.

The Boston Store.

Campau Square, at Monroe Avenue and Pearl Street, is shown in this c. 1905 card that looks northwest. At the center of the view is the old Pantlind Hotel, which was replaced by the present structure some ten years later.

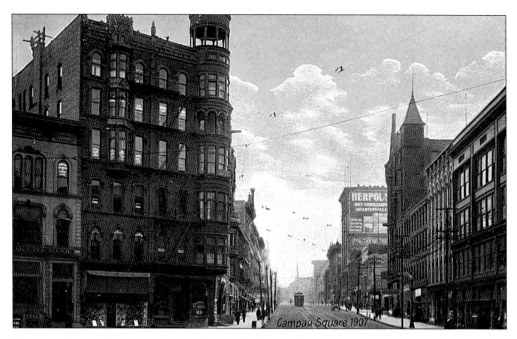

The view above, from approximately 1905, looks southeast up Monroe Avenue from Campau Square. The peaked building at the right is the Widdicomb Block, a commercial office building. Further up the street is the Herpolsheimer Store, later the Wurzburg Store. At the center left is the six-story Wonderly Block, on the site of the present McKay Tower.

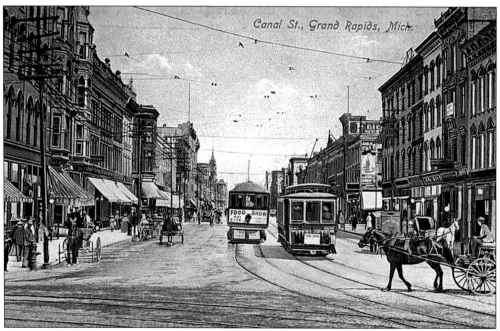

Shown here is a card looking north on Canal Street (now Monroe Avenue) from the corner of Pearl Street at Campau Square. The date is 1909.

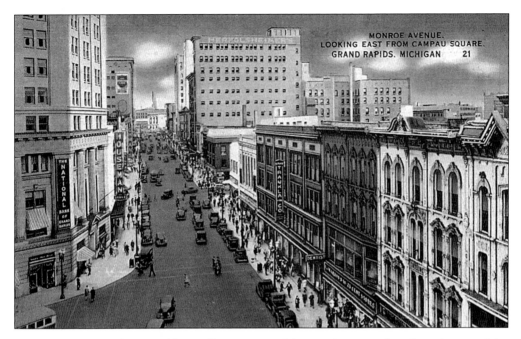

The 1930s linen card pictured here offers a view up Monroe Avenue, taken from the top of the Pantlind Hotel. The newly completed McKay Tower, then called the Grand Rapids National Bank, is on the left. On the right is the lineup of dime stores which occupied this location for decades and were torn down in the late 1970s.

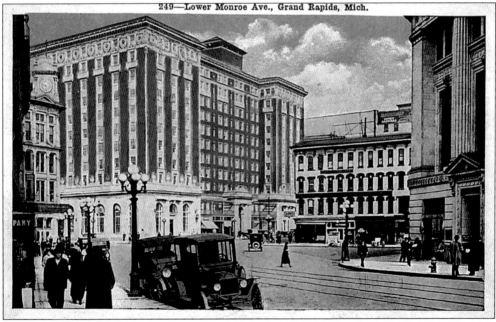

249—Lower Monroe Ave., Grand Rapids, Mich.

This 1915 view of Campau Square was captured immediately after the completion of the new Pantlind Hotel at the center.

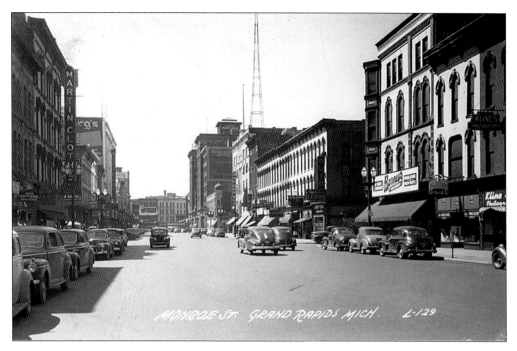

Above is a c. 1930 real-photo view of lower Monroe Avenue taken from the corner of Michigan Street, looking south toward Campau Square. During a period of unrestrained "urban renewal" during the 1960s, this entire area was razed and replaced with the present City–County complex, and eventually, the DeVos Convention Center.

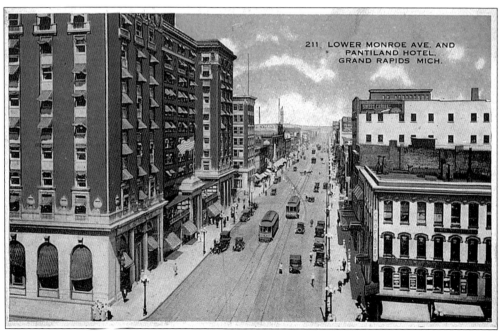

This card looks north on Canal Street (now Monroe Avenue), around 1915, after the completion of the new Pantlind Hotel at the immediate left.

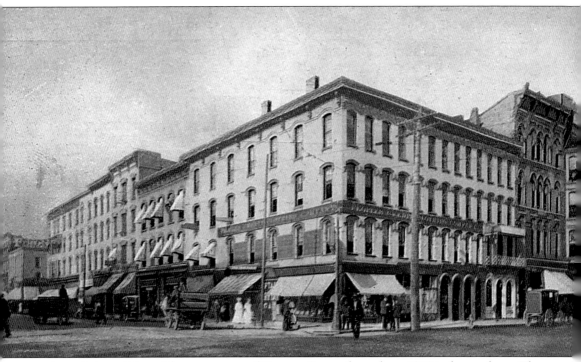

An artist's rendition of the appearance of Campau Square from about 1910 is shown above. The view looks east, up Pearl Street at the center, and Monroe Avenue to the right. To the left is

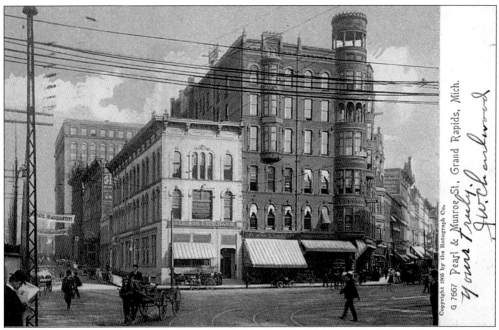

Pictured above is a view from 1900, across Campau Square looking northeast. At the center is the Wonderly Block, and in the background is the Michigan Trust Building, the tallest building in Grand Rapids at that time.

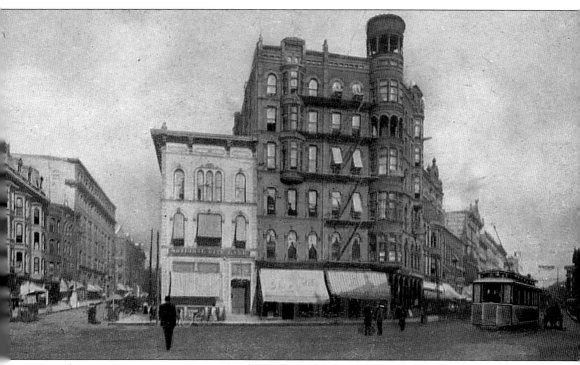

Canal Street (now Monroe Avenue). This panoramic view was sold as a single postcard, to be folded and mailed for two cents rather than the typical penny.

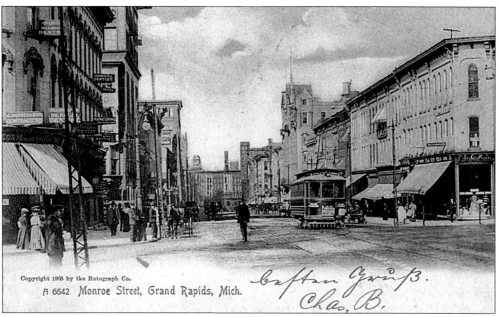

Copyright 1905 by the Rotograph Co.

A 6642 Monroe Street, Grand Rapids, Mich.

This 1905 view was taken from the corner of Division Avenue and Monroe Avenue. On the right is the Peck Drug Store, which occupied this site into the 1960s. Further down the right side of Monroe Avenue is the Morton House Hotel. The second building on the left is the Gilbert Building. At center, in the distance, is the old Pantlind Hotel at Campau Square.

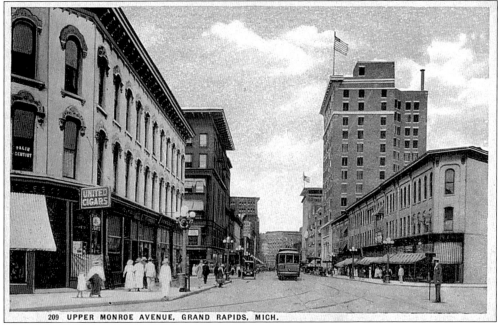

209 UPPER MONROE AVENUE, GRAND RAPIDS, MICH.

This postcard shows roughly the same view about twenty years later. The Peck Store is still on the corner at the right. The large building on the right is the Grand Rapids Savings Bank Building (later the People's Building). At center, not very distinct, is the new Pantlind Hotel at Campau Square.

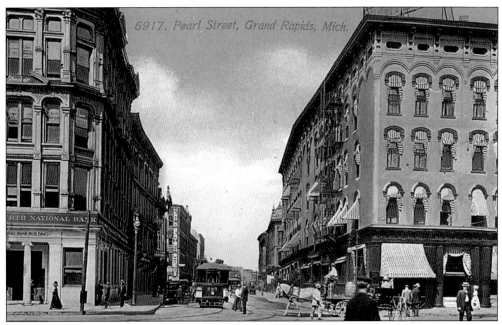

6917. Pearl Street, Grand Rapids, Mich.

Pictured here is a view of Pearl Street from 1910, looking west toward the river from the corner of Monroe Avenue. On the left is the Fourth National bank Building, which later became the local Woolworth Store; on the right is the old Pantlind Hotel.

18

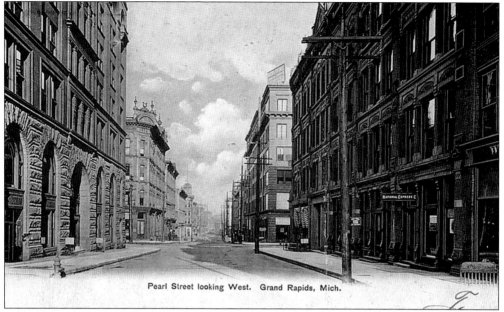

Pearl Street looking West. Grand Rapids, Mich.

Taken from the corner of Ionia Avenue, this 1906 view of Pearl Street looks west toward the river. On the right is the Houseman Building, and further down the street, the corner of the Waters Building. On the left is the Michigan Trust Building, and beyond it, the corner of the Ledyard Building. With the exception of the Houseman Building, now demolished, this view remains substantially unchanged today.

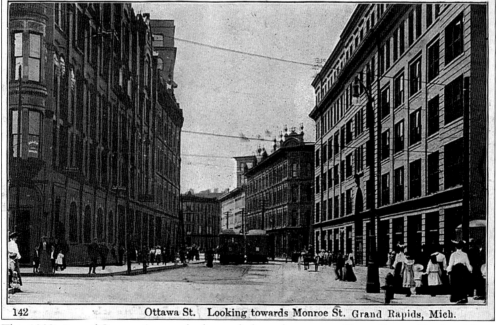

142 Ottawa St. Looking towards Monroe St. Grand Rapids, Mich.

This 1909 view of Ottawa Avenue looks south from the corner of Lyon Street. On the right is the then-10-year-old Waters Building, and beyond it the Ledyard Building. On the left is the Houseman Building, now a parking lot.

19

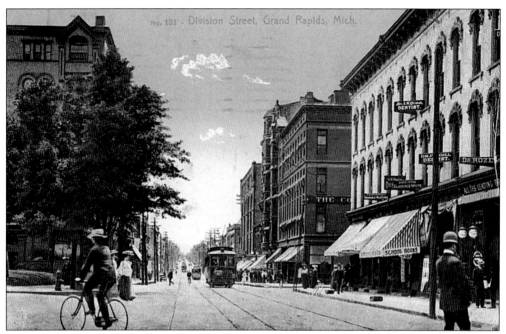

Pictured above is a 1909 view of Division Avenue, looking south from the corner of Monroe Avenue. On the left is Monument Park, on the right is the Cody Hotel, and beyond, the McMullin Office Block. Note the Grand Rapids police officer crossing the street at the right edge of the photo.

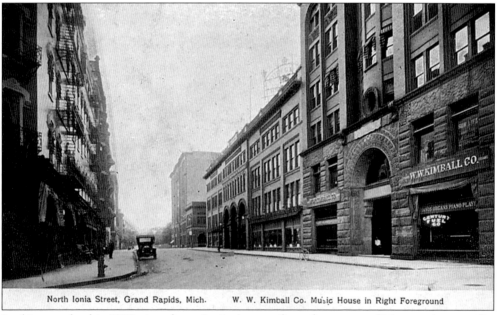

North Ionia Street, Grand Rapids, Mich. W. W. Kimball Co. Music House in Right Foreground

Looking north, this 1910 view shows Ionia Avenue from the corner of Monroe Avenue. On the right is the Temple of the Knights of Pythias, which became the Ashton Building and was later demolished. Beyond it stands the Klingman Building. On the left is the rear of the old Morton House Hotel.

South Ionia Street, Grand Rapids, Mich., showing Grand Rapids Shoe and Rubber Co. Building

This view from 1910 looks north on Ionia Avenue from the corner of Weston, near the present VanAndel Arena. Union Station would have been directly behind the photographer. Many of the structures shown still exist, though the large building at the center, the William Alden Smith Building, was destroyed by fire in the 1980s.

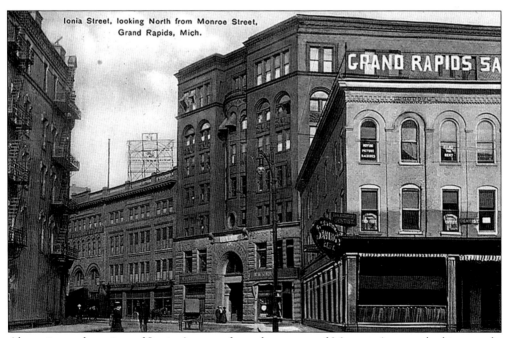

Ionia Street, looking North from Monroe Street, Grand Rapids, Mich.

Above is another view of Ionia Avenue, from the corner of Monroe Avenue, looking north. Shortly after this card was mailed in 1909, the building on the right was replaced by the Grand Rapids Savings Bank building, now called the People's Building.

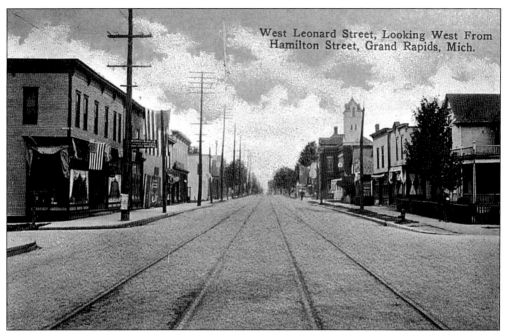

This view of West Leonard Street, looking west, dates from roughly 1909. On the right is the tower of the Leonard Street firehouse, Fire Station No.9. This card and the next are the work of Peter Oosse, a local photographer whose postcards consist largely of scenes of the west side of Grand Rapids.

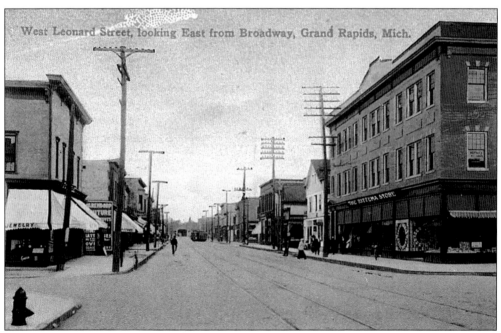

This view, looking east on Leonard Street from roughly the same spot as the previous card, also dates from around 1909.

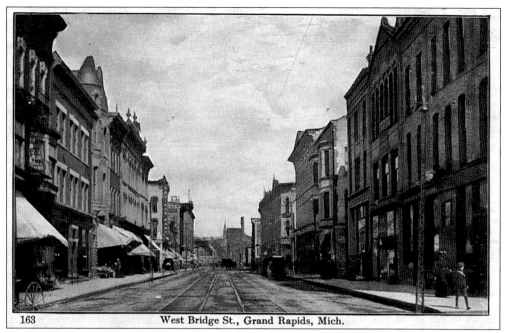

163 West Bridge St., Grand Rapids, Mich.

This card looks east on Bridge Street, on the west side of the City, about 1925. In the distance, at the center of the photo, is the Grand Rapids Brewing Company on the Michigan Street hill.

The first actual city hall for Grand Rapids was erected at the corner of Ottawa Avenue and Lyon Street in 1888. It was designed by Elijah Meyers, a Detroit architect who also designed the state capitol building. The building was razed—in the midst of much controversy—during the wave of renewal in the early 1970s, a much regretted loss. The present Kent County Courthouse sits on this site.

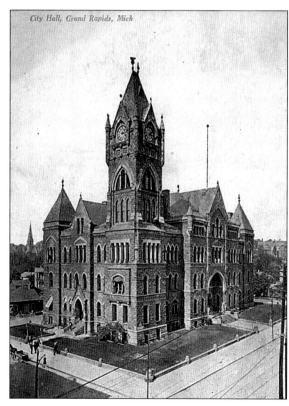

City Hall, Grand Rapids, Mich

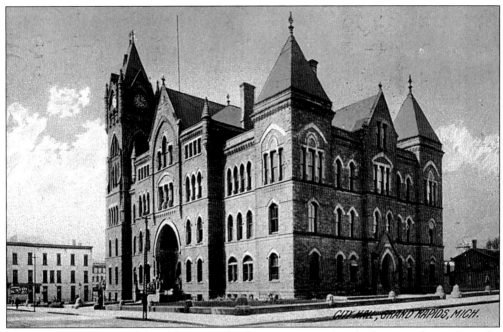

Above is another view of the old City Hall. This image was taken looking northwest from the corner of Lyon Street and Ionia Avenue.

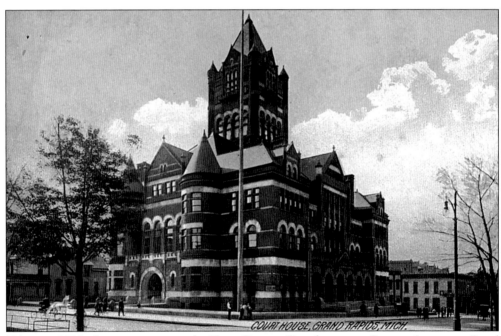

Taken in 1910, this view captures the Kent County Courthouse on Ottawa Avenue at Bond Street. The building was constructed according to the designs of local architect Sidney J. Osgood in 1892. It was in continual use until 1962, when both the courts and police department were moved to the Hall of Justice on Monroe Avenue at Michigan Street.

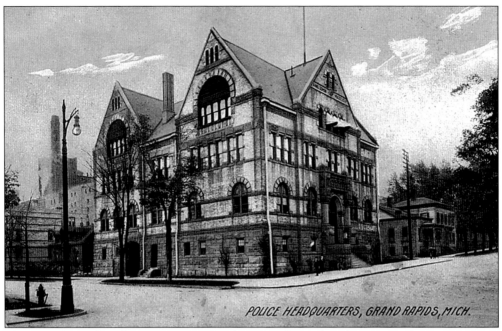

The Grand Rapids Police Department headquarters, located at the corner of Ottawa Avenue and Crescent Street, are shown here in 1908. This building, the first real headquarters of the police department, was built in 1892 and remained in use until 1962.

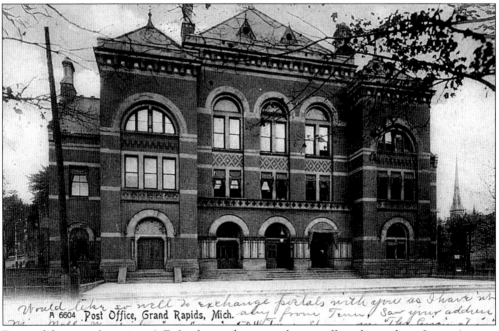

Pictured here is the original Federal courthouse and post office, located on Ionia Avenue between Pearl and Lyon Streets. This building was constructed in 1879 and used until it was replaced on the same site in 1909. This card was mailed from Grand Rapids in the same year the building was replaced.

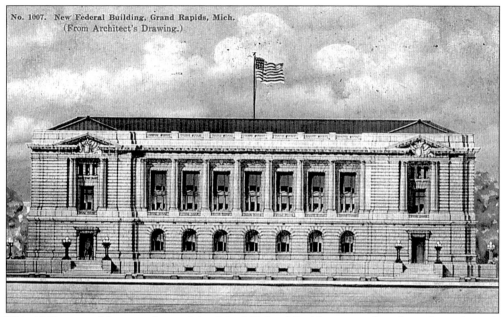

No. 1007. New Federal Building, Grand Rapids, Mich.
(From Architect's Drawing.)

This 1908 view of the west front of the "new" Federal Building was taken from the architect's rendering. This building was completed in 1909, with the cornerstone being laid by Alice, the daughter of President Theodore Roosevelt. Her appearance for the ceremony caused quite a stir, as she was smoking a cigarette. This building was used until 1966, when a new Federal Building was completed. The Grand Rapids Art Museum is presently housed here.

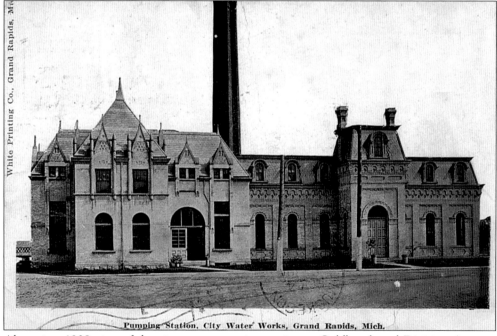

White Printing Co., Grand Rapids, Mi

Pumping Station, City Water Works, Grand Rapids, Mich.

Above is a 1908 view of the city water pumping station at Coldbrook and Division Avenue; the station was built in 1874.

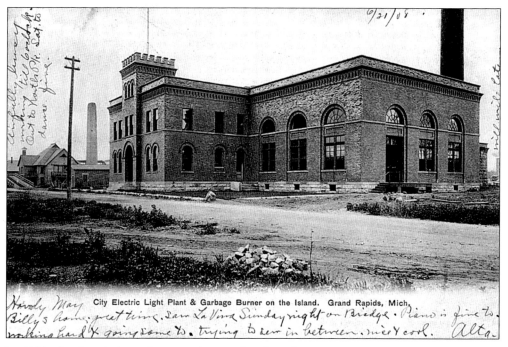

City Electric Light Plant & Garbage Burner on the Island. Grand Rapids, Mich.

In 1908, the City light and power plant and garbage burning facility were located on a now vanished island in the Grand River south of Leonard Street.

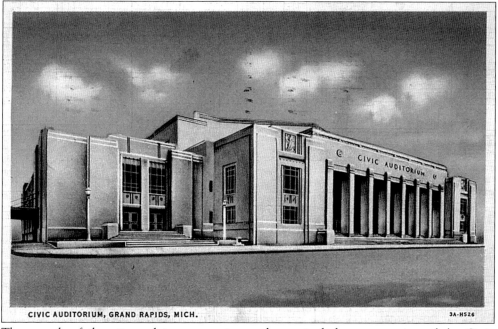

CIVIC AUDITORIUM, GRAND RAPIDS, MICH. 3A-H526

The growth of the city and its convention trade required the construction of the Civic Auditorium in 1933. Located behind the present DeVos Hall, the building enjoyed heavy use, until supplanted by the DeVos Convention Center in 2002. The auditorium was then razed, but the Art Deco façade, pictured here in 1935, was preserved.

27

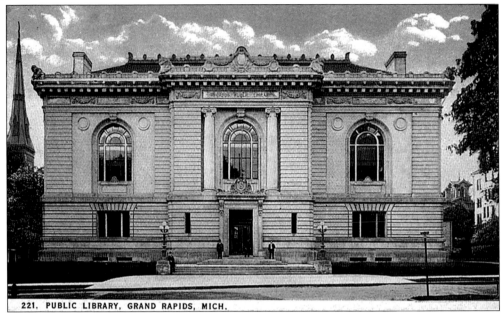

221. PUBLIC LIBRARY, GRAND RAPIDS, MICH.

Captured in 1915, this image shows the Grand Rapids Public Library at the corner of Bostwick Avenue and Library Street. The library was first organized in 1858, but struggled financially for the next 40 years, with no real home of its own. In 1901, Martin A. Ryerson, a Chicago philanthropist and descendant of city founder, Louis Campau, offered to construct this building. The gift was accepted, and the facility opened in 1904. In 1966, a large addition was constructed at the rear of this building. The original Ryerson Building, and the addition, were renovated in 2004.

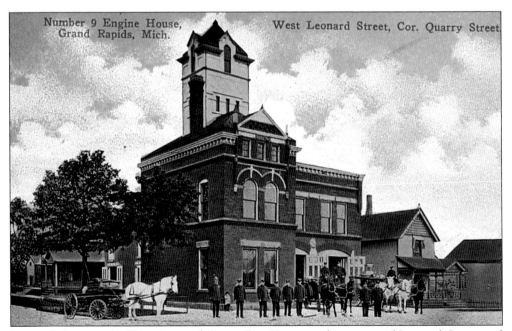

Pictured above is the West Leonard Street Fire House at the corner of Leonard Street and Quarry Avenue in 1912.

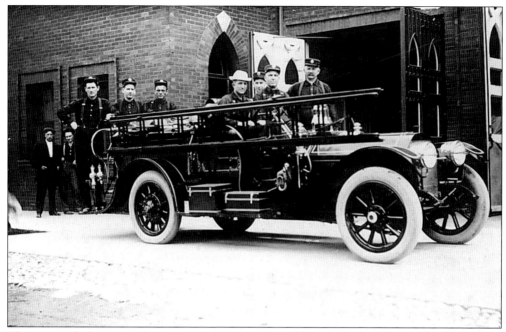

This rare real-photo card depicts a local fire company. The message written on the back of the card, dated July 1910, states: "This is the first fire-auto in Grand Rapids. Notice father up in front. It is a pretty good picture of the men. . . . Only three of the boys were not there."

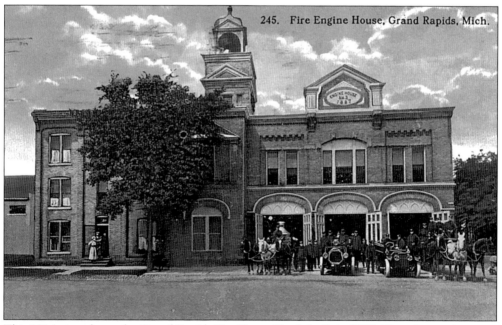

245. Fire Engine House, Grand Rapids, Mich.

This 1914 view shows the Grand Rapids Fire House No. 3, built in 1887. Note the combination motor and horse-drawn fire engines.

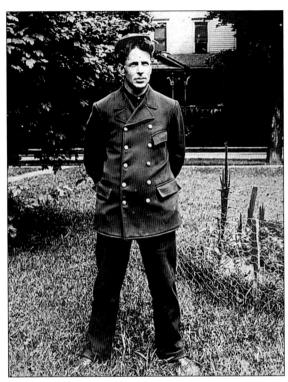

Seen at left is a real-photo postcard portrait of Fireman Jesse W. Smith, taken around 1907 when he was hired by the Grand Rapids Fire Department. Smith was stationed downtown at Engine House No. 1.

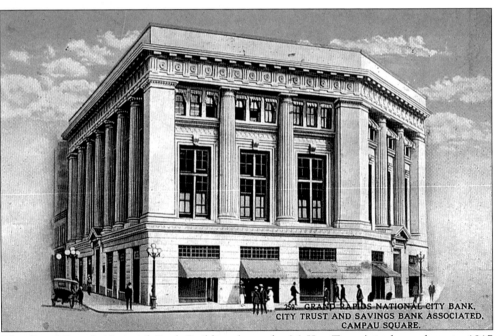

259. GRAND RAPIDS NATIONAL CITY BANK,
CITY TRUST AND SAVINGS BANK ASSOCIATED.
CAMPAU SQUARE.

The Grand Rapids National Bank Building (now the McKay Tower) is shown here in 1917 at the corner of Pearl Street and Campau Square. Constructed in 1916, the building received an eleven-story addition in 1927. This brought the structure to its present form, making it the tallest building in Grand Rapids for 60 years.

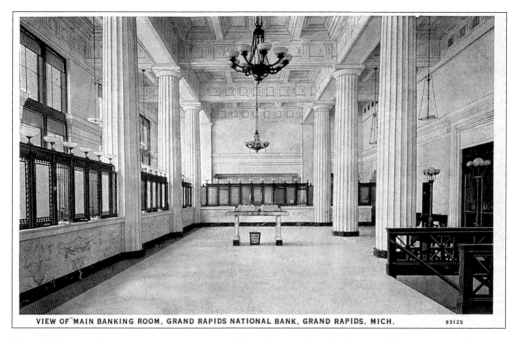

VIEW OF MAIN BANKING ROOM, GRAND RAPIDS NATIONAL BANK, GRAND RAPIDS, MICH. 93125

This 1916 card shows an interior view of the Grand Rapids National Bank, located in the present McKay Tower.

The above view of the Grand Rapids National Bank Building, located at Campau Square, was taken in 1935 from the roof of the Pantlind Hotel. This bank, along with several others in the city, failed at the height of the Depression. The building was then acquired by local politico, Frank McKay who renamed it for himself and developed the property as commercial office space.

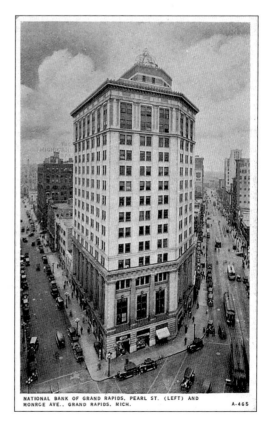

NATIONAL BANK OF GRAND RAPIDS, PEARL ST. (LEFT) AND
MONRGE AVE., GRAND RAPIDS, MICH. A-465

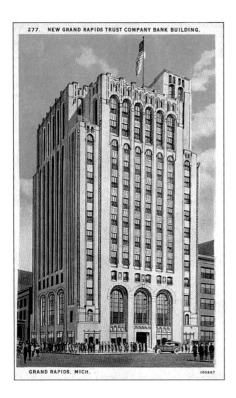

277. NEW GRAND RAPIDS TRUST COMPANY BANK BUILDING.

GRAND RAPIDS, MICH. 105887

The Grand Rapids Trust Company, now the Michigan National Bank Building (Standard Federal), is shown at right at the time of its construction in 1926.

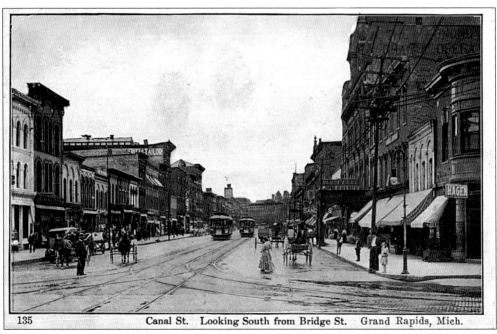

135 Canal St. Looking South from Bridge St. Grand Rapids, Mich.

This view of Lower Monroe Avenue (formerly Canal Street) was captured about 1910. On the right is the former site of the Hall of Justice, the present site of the DeVos Convention Center.

32

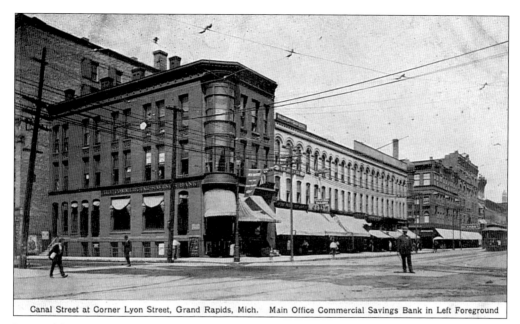

Canal Street at Corner Lyon Street, Grand Rapids, Mich. Main Office Commercial Savings Bank in Left Foreground

Pictured here is a view of Canal Street (Lower Monroe Avenue) looking north from about 1908. The Commercial Savings Bank building is on the corner at center. This block is the site of the DeVos Convention Center. Note the helmeted police officer at the right center.

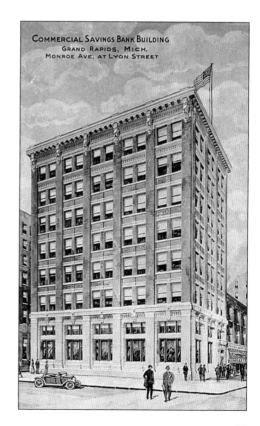

Taken around 1925, this view shows the newly constructed Commercial Savings Bank Building located at Lyon Street and Monroe Avenue (formerly Canal Street).

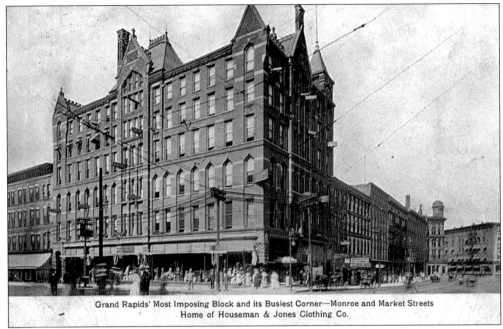

Grand Rapids' Most Imposing Block and its Busiest Corner—Monroe and Market Streets
Home of Houseman & Jones Clothing Co.

This view from 1909 depicts the Widdicomb Block at the corner of Market Street and Monroe Avenue (the site of the present Rosa Parks Circle). To the right is Campau Square and the old Pantlind Hotel.

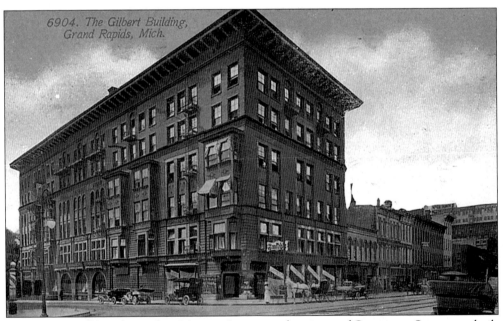

6904. The Gilbert Building,
Grand Rapids, Mich.

The Gilbert Building, located on Monroe Avenue at the corner of Commerce Street, was built in 1866 by local businessman Francis B. Gilbert. The building still stands and is used for its originally intended, mixed commercial purpose. The cross street running on the east side of the building, Commerce Avenue, was closed in 1950, when the new Herpolsheimer Store was built, spanning the former street space.

This view of the Grand Rapids Savings Bank Building—located at the northeast corner of Monroe and Ionia Avenues—was taken in the fall of 1916 when Harry Gardner, "The Human Fly," scaled its heights. It is now the People's Building.

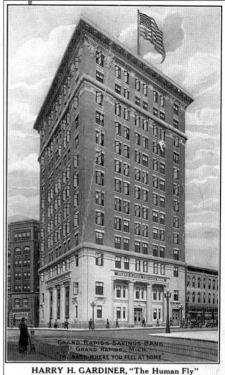

HARRY H. GARDINER, "The Human Fly"
Climbing Grand Rapids Savings Bank Building
September 20, 1916

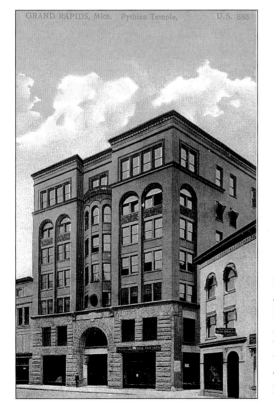

Built by members of the fraternal society on the designs of member A.W. Rush, the Pythian Temple on Ionia Avenue at Monroe Avenue is shown here in 1910. The building was later renamed the Ashton Building and was much favored as a location for dental offices. It was razed in the 1970s to provide parking space.

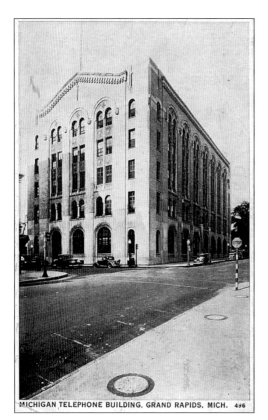

MICHIGAN TELEPHONE BUILDING, GRAND RAPIDS, MICH. 496

The Telephone Company Building at Division Avenue and Fountain Street is shown here around 1930. This structure was built in 1920 to house the newly merged local Citizen's and Bell Telephone services.

The original Masonic Temple in Grand Rapids, shown here around 1909, was located at the intersection of Ionia, Louis, and Fulton Streets. Though originally constructed as the local temple for various Masonic organizations, the building later housed the showrooms of the Bishop Furniture Company and a number of professional offices.

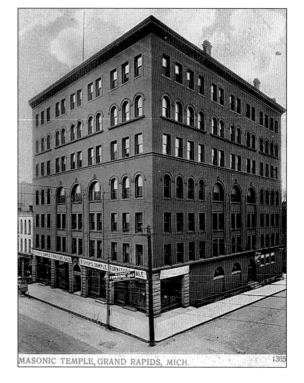

MASONIC TEMPLE, GRAND RAPIDS, MICH. 1365

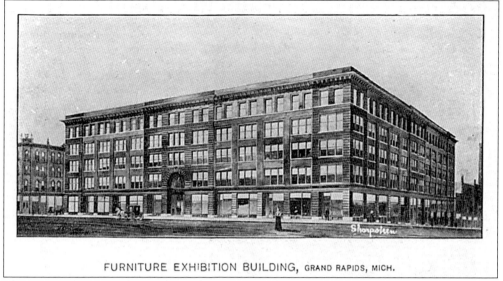

FURNITURE EXHIBITION BUILDING, GRAND RAPIDS, MICH.

This very early postcard view shows the Waters Building, located on Ottawa Avenue between Pearl and Lyon Streets, at the time of its construction in 1899. It was designed for the specific purpose of providing display space for the rapidly growing furniture market in Grand Rapids. When the building was actually finished, a sixth floor had been added.

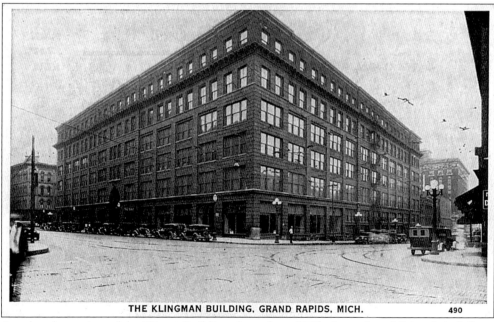

THE KLINGMAN BUILDING, GRAND RAPIDS, MICH. 490

Another, later, view of the Waters Building, from about 1925, shows the additional sixth floor. Unlike many of its original contemporaries, this building, though now over a century old, has adapted and survived well as commercial office space.

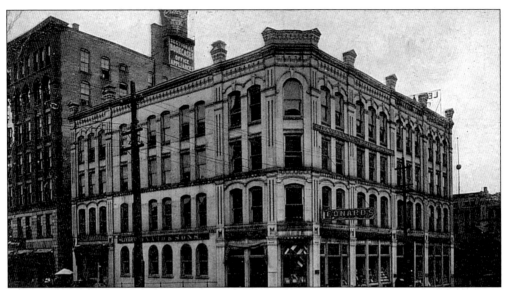

The commercial headquarters of H. Leonard & Sons, purveyors of china, glass, and household wares, is pictured in 1910. The Leonard family later expanded into the manufacture of iceboxes and refrigerators as the Grand Rapids and Leonard Refrigerator Companies, and later the Kelvinator Company. This is a commercial card, used by Leonard Company salesmen to confirm orders from wholesale customers.

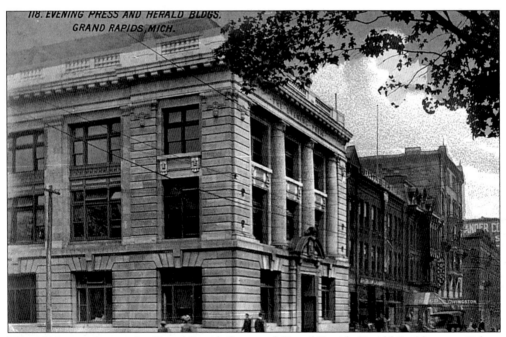

This 1911 view depicts the Grand Rapids Press and Grand Rapids Herald Buildings on Fulton Street just east of Division Avenue. They stood side by side, despite their competitive status. The *Grand Rapids Press* was published in the evening, while the *Grand Rapids Herald* was a morning paper. The Grand Rapids Press Building, built in 1906, was one of the first buildings in the world to make use of reinforced concrete in its construction. Both buildings were razed in the 1960s.

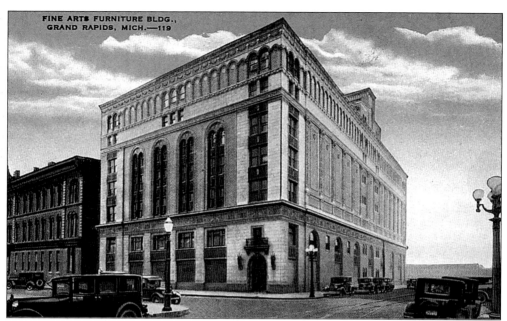

The Fine Arts Furniture Building, located on Lyon Street at the Grand River, began as a nondescript factory building on the river's edge. In 1925, the building was refaced with elaborate polychrome terra cotta, in the Italian Renaissance style, as depicted in this card from the late 1920s. Originally used as furniture display space, the building was incorporated into the Amway Grand Plaza Hotel in 1982; it presently houses commercial office space.

The Michigan Trust Building, located at the southeast corner of Ottawa Avenue and Pearl Street, is shown here about 1912. At the time of its construction by the financial management company (later absorbed into the Old Kent Bank) this was the tallest building in the State of Michigan. The small, one-story building at the right was later demolished, and an addition to the original Trust Building was added. The building continues in its originally intended use today, as commercial office space.

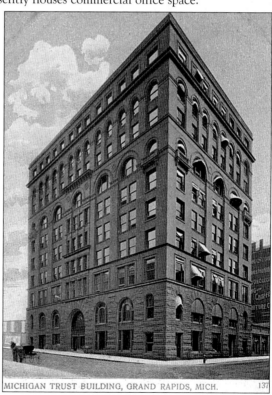

MICHIGAN TRUST BUILDING, GRAND RAPIDS, MICH. 137

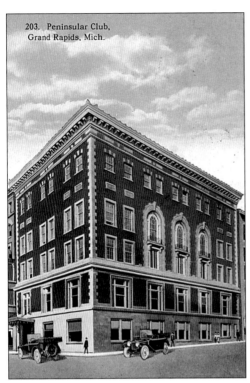

203. Peninsular Club,
Grand Rapids, Mich.

The Peninsular Club, a private business club, was founded in 1881 at the corner of Ottawa Avenue and Fountain Street. Its original clubhouse was replaced in 1914 by this more commodious structure, designed by local architects Robinson and Crowe. The card dates from 1915.

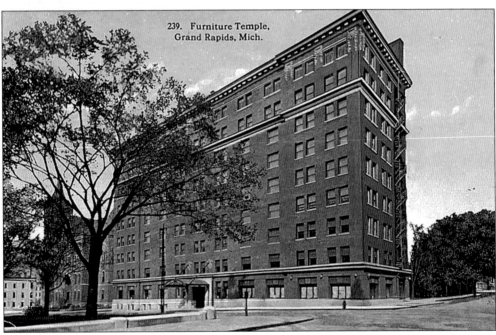

239. Furniture Temple,
Grand Rapids, Mich.

This 1915 view shows the present-day Commerce Building, located on Lyon Street, between Ionia and Division Avenues. In its original form, as the Furniture Temple, built around 1910, it provided office and display space for the booming local furniture industry. The use of a hipped roof, not visible in this view, is unusual for a building of this size and height.

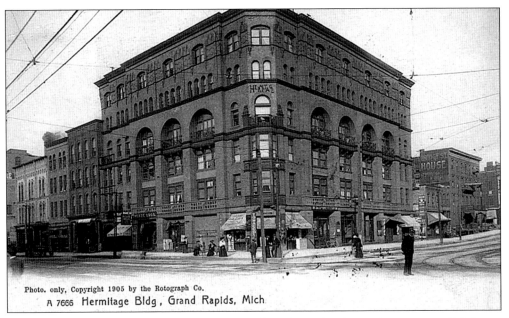

A 7666 Hermitage Bldg, Grand Rapids, Mich

Pictured above is a 1905 view of the Hermitage Building, located at the northeast corner of Michigan Street and Monroe Avenue; it is the present site of the Grand Rapids Press. Over its lifetime, this building operated as several different hotels, attracted to the site by the proximity of the Grand Trunk Railway Station, one block to the west, on the eastern bank of the Grand River.

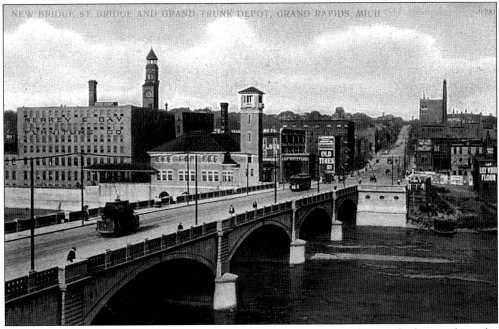

This view across the Bridge (Michigan) Street Bridge, from around 1910, looks east from the west bank of the River. The tower at the center of the picture is part of the Grand Trunk Railway Station, demolished in 1960 for the present U.S. Post Office. To the left is one of the Berkey and Gay furniture factories.

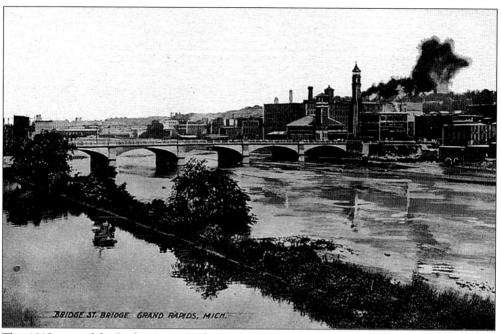

This 1915 view of the Bridge Street Bridge, again from the west side of the River, shows not only the bridge and east bank of the river, but also one of the canals running along the west bank of the River. The canals were originally constructed for the generation of power for factories.

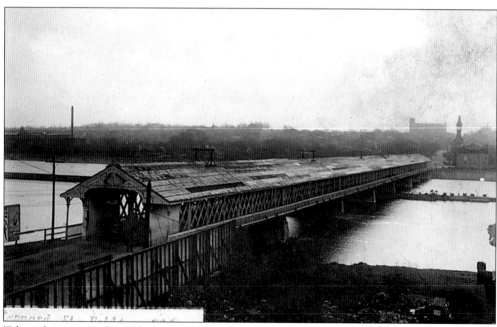

Taken about 1910, this real-photo postcard depicts the original Leonard Street bridge across the Grand River. The bridge was originally constructed as a privately-owned toll bridge in 1857. It was purchased by the City in 1873, and replaced in 1913 by a cement span.

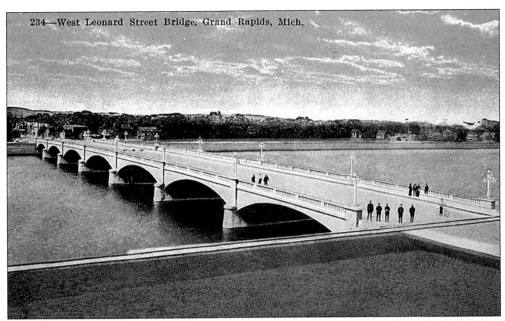

234—West Leonard Street Bridge, Grand Rapids, Mich.

The cement bridge which replaced the original covered span on Leonard Street was built in 1913. It was in use until it was replaced, once again, in the late 1970s.

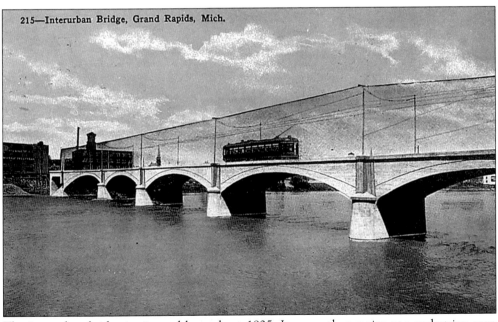

215—Interurban Bridge, Grand Rapids, Mich.

The interurban bridge is pictured here about 1925. It presently remains as a pedestrian span across the river between Pearl and Bridge Streets. The curious netting shown in the picture was apparently erected to keep insects hatching in the river from fouling the mechanics of the electrically powered streetcars and bothering their passengers as they crossed the river.

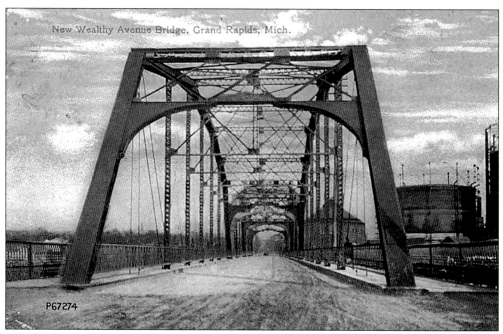

This 1914 view depicts the "new" Wealthy Street Bridge across the Grand River, looking east across the steel-span bridge. On the right, the storage tanks of the local gas company are visible.

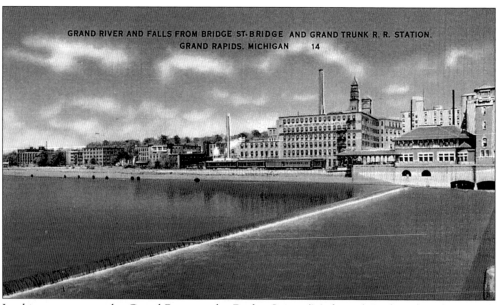

Looking east across the Grand River at the Bridge Street (Michigan) Bridge, this photograph was taken about 1935. At the right is the Grand Truck Railroad Station, and at center is one of the factories of the Berkey and Gay Furniture Company. The line across the river at center is one of several dams installed over the years to allow utility connection to the west side of the city, and to level out the rapids which had originally attracted settlers to this area more than one hundred years before.

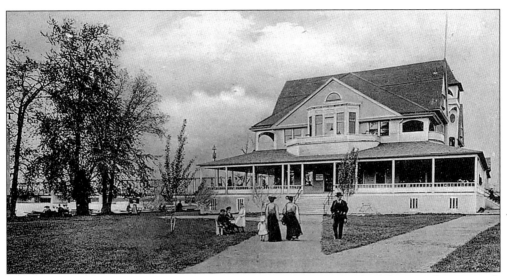

This 1900 view shows the pavilion at North Park on the eastern bank of the Grand River north of downtown. The card showcases the south side of the pavilion, now demolished, with the North Park Bridge visible in the left background.

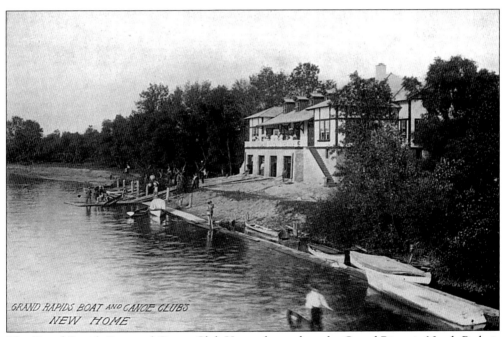

The Grand Rapids Boat and Canoe Club House, located on the Grand River in North Park, is pictured here about 1910. This building was erected in 1902 and provided for the very popular rowing and sculling activities of its members until it closed in 1929.

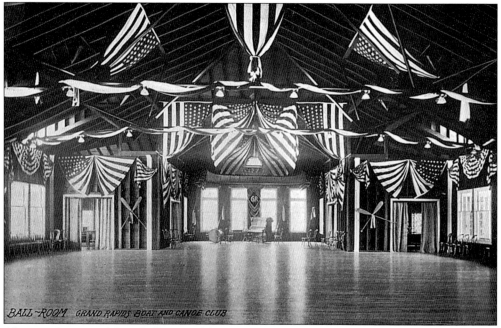

Above is the second-floor ballroom of the Grand Rapids Boat and Canoe Club House.

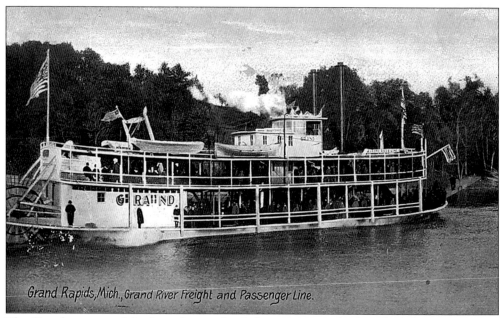

The *Grand* was one of the last of many freight/passenger vessels that plied the Grand River. This ship and a sister ship were launched in 1905, and ran between Grand Rapids and Spring Lake on the river. The Grand Rapids and Lake Michigan Transportation Company failed a couple of years later.

Two

LIFE IN THE CITY

As Grand Rapids grew in the late 19th and early 20th centuries, commercial, religious, and social activity kept pace with the burgeoning population. Schools, churches, and theaters rose, reflecting the wants and needs of the people.

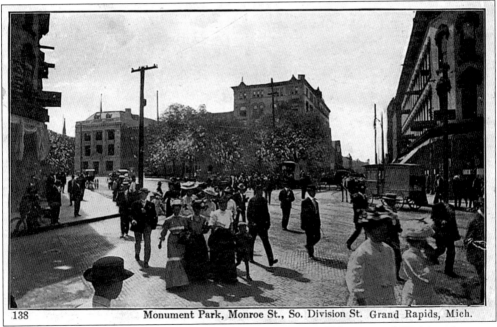

138 Monument Park, Monroe St., So. Division St. Grand Rapids, Mich.

This view from 1908 shows a busy day at the intersection of Monroe and Division Avenues, near the literal center of the city. To the left is Monument Park; it was established at the end of the Civil War in 1865 to host a large veterans' monument which was to come several decades later. Behind the park is the Livingston Hotel, and to the extreme left is the newly constructed Grand Rapids Press Building. On the extreme right is a commercial block later replaced by the Herpolsheimer Store, in the 1950s, and still later occupied as the headquarters of the Grand Rapids Police Department.

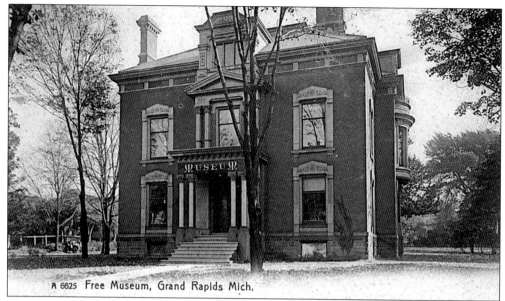

A 6625 Free Museum, Grand Rapids Mich.

This 1905 view showcases the Kent Scientific Museum, located in the former Howlett home at the corner of Jefferson Avenue and Washington Street. Founded by a group of local enthusiasts, this was the first such museum in the city. It housed a collection of cultural and natural history items which were of high interest to the people of its day. The building was replaced in 1940 by the Grand Rapids Public Museum on the same site. The museum later moved to new quarters on the west bank of the river at Pearl Street.

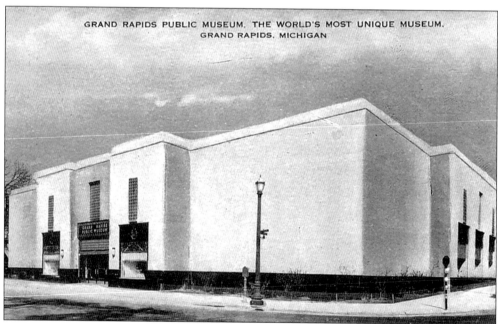

GRAND RAPIDS PUBLIC MUSEUM. THE WORLD'S MOST UNIQUE MUSEUM. GRAND RAPIDS, MICHIGAN

Dedicated in 1940, this building replaced the earlier Kent Scientific Museum on the same site. It remained in use until the 1990s, when the museum moved to its present facility on the river at Pearl Street. This view is from around 1940.

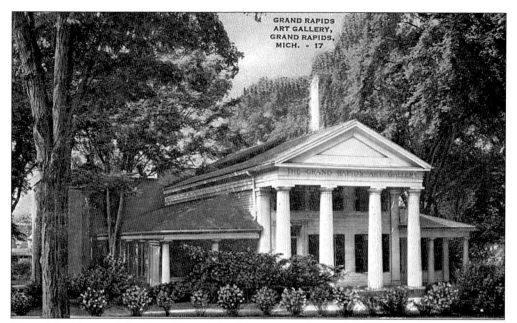

The original home of the Grand Rapids Art Museum, on the south side of Fulton Street between Lafayette and Jefferson Avenues, is pictured in a linen card from around 1945. The museum was housed in the former Abram Pike House, a fine and important example of the vernacular Greek Revival architectural style. The building was constructed in 1845, and larger gallery space was later added at the rear. The museum moved from this site to its present location in the former Federal Building in 1982.

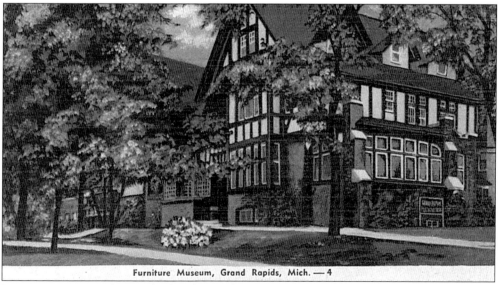

Furniture Museum, Grand Rapids, Mich. — 4

Beginning in 1936 during the heyday of the local furniture market, the former T. Steward White home, on the south side of Fulton Street just east of College Avenue, was used as the Grand Rapids Furniture Museum. Dwindling attendance forced the closure of the museum in 1959, when its collections were merged into that of the Grand Rapids Public Museum. This building is presently part of the campus of Davenport University.

49

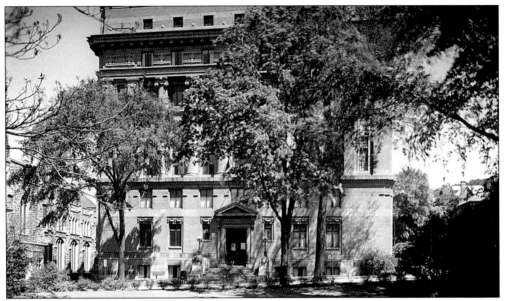

This 1950 real-photo picture shows the Masonic Temple, located on the north side of Fulton Street between Jefferson and Lafayette Avenues. This building was built in 1917, replacing the previous temple located at Ionia and Fulton Streets (page 36). After suffering damage in a fire in 1947, the temple was refurbished and continues to be used for Masonic and office purposes today. The card is interesting for its depiction of the trees, since removed, which were still common along downtown streets at this time.

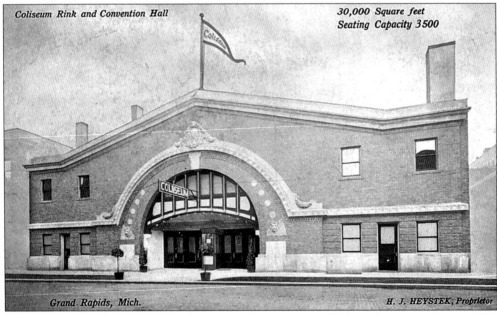

The Coliseum Building, located on Commerce Avenue south of Fulton Street, was built in 1910 by Henry G. Heystek. It was used as a local convention and entertainment facility. In 1917, shortly after its construction, Theodore Roosevelt and Charles Evans Hughes campaigned for president here. The building still stands, though it is now used for commercial purposes.

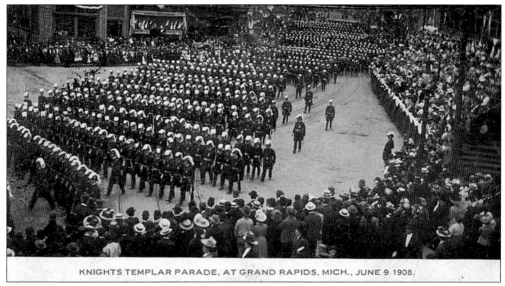

KNIGHTS TEMPLAR PARADE, AT GRAND RAPIDS, MICH., JUNE 9 1908.

This card captures a parade on Monroe Avenue during the annual convention of the Knights Templar, a national Masonic organization, in June 1908. Parades of this sort were common, and very popular events during this era before telephones, movies, and later television provided other forms of popular entertainment.

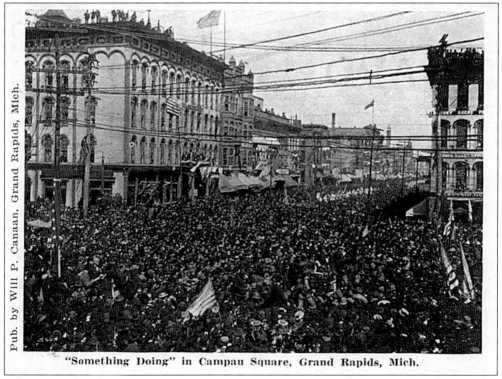

Pub. by Will P. Canaan, Grand Rapids, Mich.

"Something Doing" in Campau Square, Grand Rapids, Mich.

A huge crowd gathers in Campau Square and Monroe Avenue. The occasion for the assembly is thought to be the departure of local troops for service in the Spanish American War during April 1898.

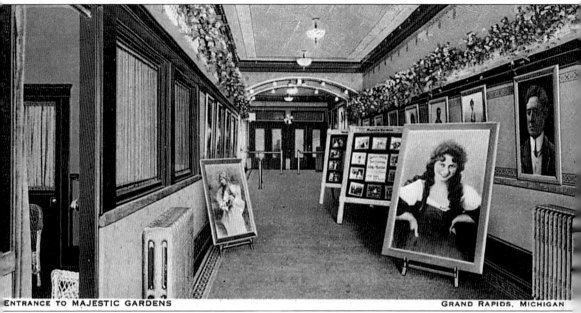

ENTRANCE TO MAJESTIC GARDENS | GRAND RAPIDS, MICHIGAN

This is a rare commercial double card from 1903 intended to be folded and mailed to publicize the new Majestic Gardens Theater at the corner of Division Avenue and Library Street. The Majestic opened in 1903 as a legitimate theater, hosting many traveling actors of the day; it was

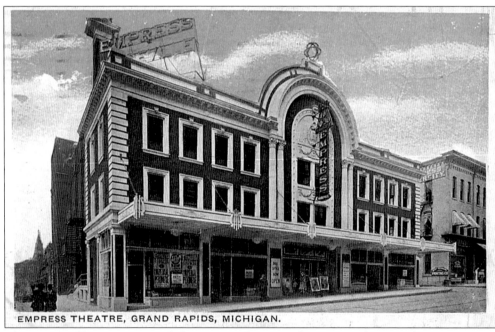

EMPRESS THEATRE, GRAND RAPIDS, MICHIGAN.

The Empress Theater is pictured above in 1915, a year after it opened. Located on Lyon Street between Monroe and Ottawa Avenues, the Empress was the center of Vaudeville theater in Grand Rapids, though later rivaled by the Ramona Theater at Reeds Lake. It was eventually renamed the Keith's Movie Theater, and finally razed in the 1960s, at the same time as the nearby Regent.

52

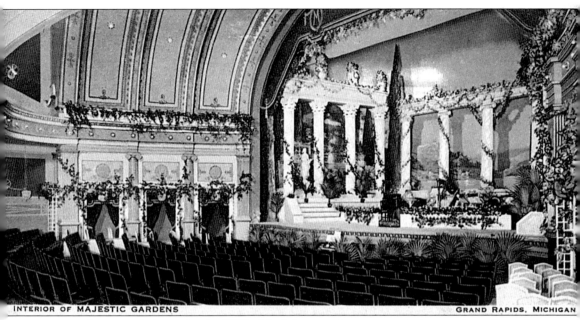

INTERIOR OF MAJESTIC GARDENS — GRAND RAPIDS, MICHIGAN

converted to a movie house in the 1930s. Much later, as downtown movie attendance flagged, the Majestic was returned to its former theatrical glory as the permanent home of the Grand Rapids Civic Theater, which still thrives at this location.

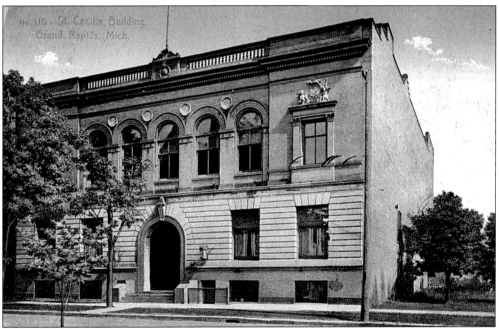

The St. Cecilia Society, located on Ransom Avenue just north of Fulton Street, was founded in 1886 to promote the appreciation and performance of music, for whose patron saint the society is named. This impressive Italian Renaissance building, still in constant use as a performance venue, was built by the women of the society shortly after the group was founded. The auditorium in the building is renowned for its superb acoustics. This view dates from 1910.

53

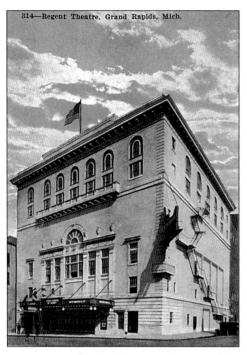

314—Regent Theatre. Grand Rapids, Mich.

The Regent Theater, located on Bond Street near Monroe Avenue, was demolished as part of the urban renewal wave of the 1960s. This grand and elaborate movie palace was built in 1923 at a reported cost of one million dollars; it included a roof garden for summer evening entertainment.

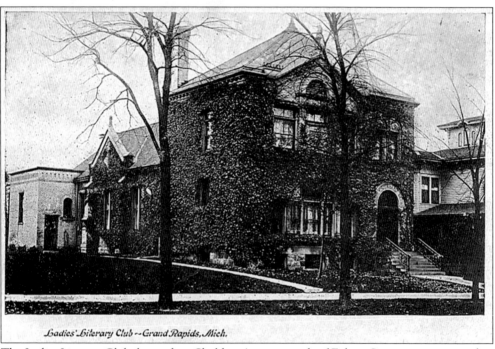

Ladies' Literary Club -- Grand Rapids, Mich.

The Ladies Literary Club, located on Sheldon Avenue south of Fulton Street, was organized in 1873 as the second women's club in the State of Michigan. This clubhouse, designed by local architect W. G. Robinson, was erected in 1887; it was the first of its kind in the United States. Club members were instrumental in establishing the Public Library and Art Museum in Grand Rapids. The building continues in regular use as a site for many cultural activities.

The Monroe Avenue headquarters of the Steketee Department Store are shown here around 1920. This location for the firm first opened in 1878, but the current building came sometime later. The firm continued in operation until the late 1990s.

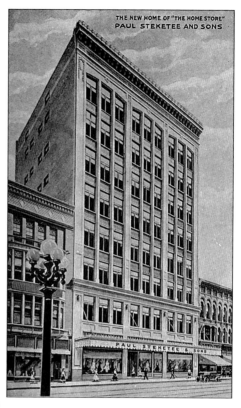

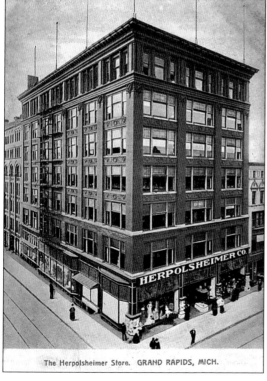

The Herpolsheimer Store. GRAND RAPIDS, MICH.

This 1900 view of the Herpolsheimer Store, located at the corner of Ionia and Monroe Avenues, shows the store's location from its beginning in 1886 up until to 1951, when it moved to larger quarters at Monroe and Division Avenues. After 1951, this building was occupied and expanded by the Wurzburg Store, until it was vacated and razed in the early 1970s.

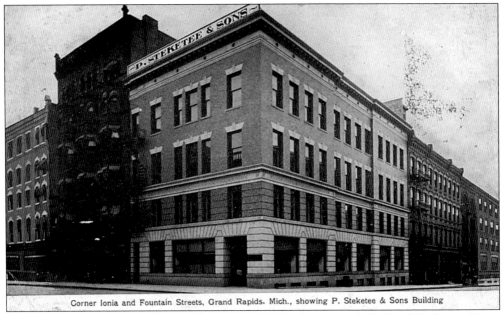

Corner Ionia and Fountain Streets, Grand Rapids. Mich., showing P. Steketee & Sons Building

Taken around 1909, this photograph shows the rear entrance of the Paul Steketee Store, located at the corner of Fountain Street and Ionia Avenue. At the extreme left is the rear of the old Morton House Hotel.

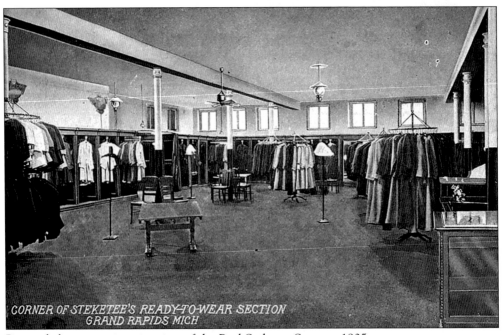

CORNER OF STEKETEE'S READY-TO-WEAR SECTION
GRAND RAPIDS MICH

Pictured above is an interior view of the Paul Steketee Store, c. 1905.

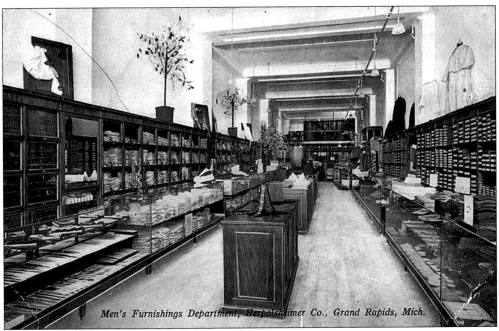

Men's Furnishings Department, Herpolsheimer Co., Grand Rapids, Mich.

This interior view of the Herpolsheimer Store dates from about 1905.

A MODERN GRAND RAPIDS CLOTHING STORE

CLOTHING DEPT. OF "THE GIANT" A. MAY & SONS

Over 5,000 garments carried on individual hangers in dust-proof cabinets. The first clothing store in the world equipped in this manner. This "New Way" assures every customer of getting clothes that are in perfect shape, free from dust or wrinkles. The high quality of our merchandise compelled us to install this system.

This 1909 commercial card was sent out by the Giant Clothing Store, founded in 1883 and operated by A. May and Sons. The building was located at the southeast corner of Monroe Avenue and Lyon Street. Renamed May and Company, the store remained in this location until the late 1970s, when it closed and the building was demolished. As this card indicates, the presentation of men's clothing in the May Store on hangers, rather than folded and stacked, was new and unusual. The May Store was the first in the United States to make use of the new "clothing hanger" method of display.

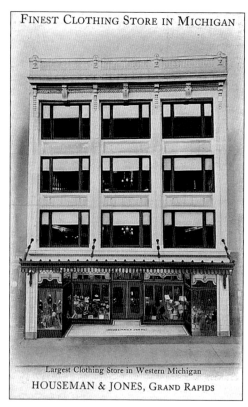

FINEST CLOTHING STORE IN MICHIGAN

Largest Clothing Store in Western Michigan

HOUSEMAN & JONES, GRAND RAPIDS

The store of the Houseman and Jones Company, located on Monroe Avenue at Campau Square, is pictured above. This firm, one of the oldest retail operations in Grand Rapids, was founded by cousins Joseph and Julius Houseman in 1852. In addition to a full clothing line, the company also manufactured and sold clothing for lumberjacks during the timber boom in Northern Michigan. The firm closed in the 1970s.

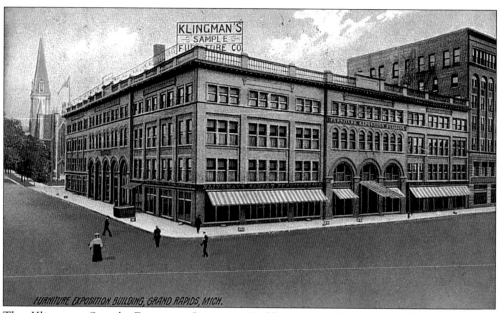

FURNITURE EXPOSITION BUILDING, GRAND RAPIDS, MICH.

The Klingman Sample Furniture Company Building, located at the southeast corner of Fountain Street and Ionia Avenue, is pictured here about 1905. On the right is the now demolished Ashton Building, and in the background at the left, the Victorian steeple of the old Fountain Street Church.

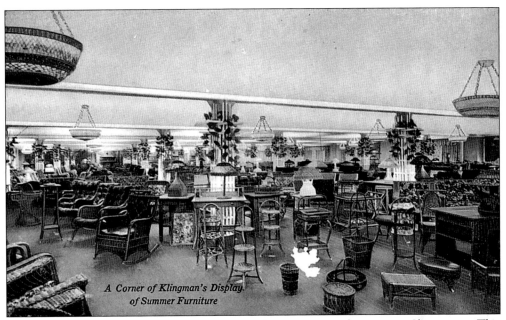

A Corner of Klingman's Display of Summer Furniture

This 1908 images captures an interior view of the Klingman Sample Furniture Showrooms. This company specialized in the retail sale of furniture which had been displayed in the frequent wholesale furniture conventions and markets in Grand Rapids.

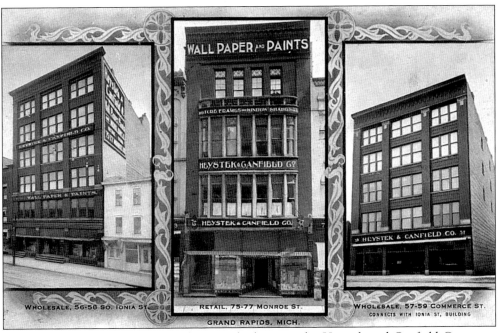

Dating from 1915, this commercial postcard advertises the Heystek and Canfield Company, wholesale and retail sellers of paints and wallpapers.

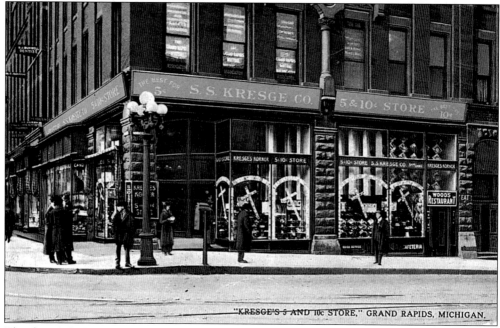

"KRESGE'S 5 AND 10¢ STORE," GRAND RAPIDS, MICHIGAN.

The first S.S. Kresge Store in Grand Rapids was located on the ground floor level of the Widdicomb Building at the corner of Market and Monroe Avenues. This photograph was taken in 1905.

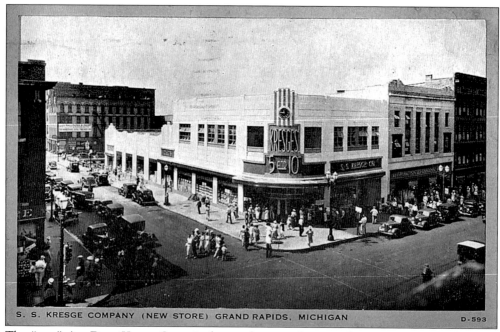

S. S. KRESGE COMPANY (NEW STORE) GRAND RAPIDS, MICHIGAN D-593

The "new" Art Deco Kresge Store is shown above at the same location in 1928. The store remained in operation until about 1980 when it was removed, along with its neighbors, to allow the extension of Monroe Avenue and the creation of Rosa Parks Circle.

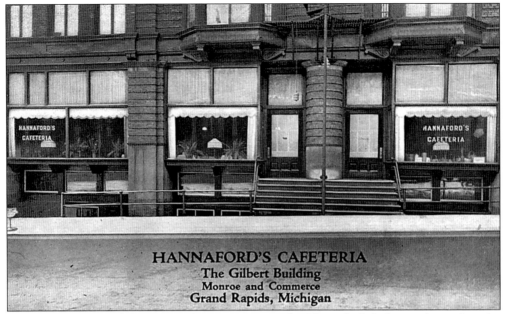

HANNAFORD'S CAFETERIA
The Gilbert Building
Monroe and Commerce
Grand Rapids, Michigan

This commercial card from around 1920 promotes the Hannaford Cafeteria, located in the Gilbert Building on the south side of Monroe Avenue between Division and Ionia.

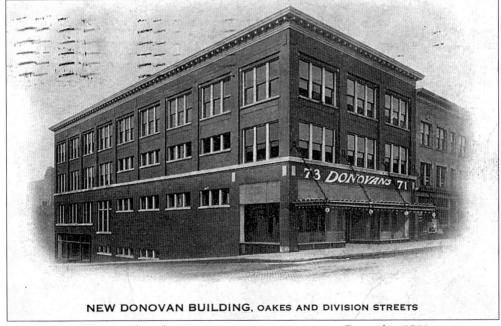

NEW DONOVAN BUILDING, OAKES AND DIVISION STREETS

This card, a promotional mailing to customers, was sent out in December 1911 to announce the relocation of the Donovan Clothing Store to 71 South Division Avenue at the corner of Oakes Street.

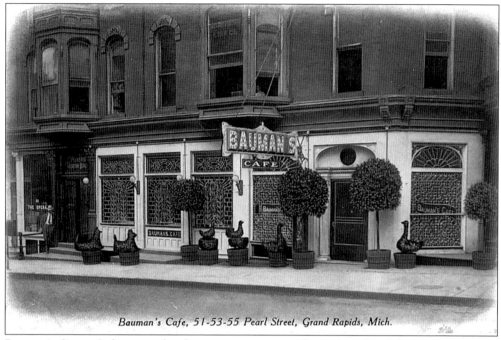

Bauman's Cafe, 51-53-55 Pearl Street, Grand Rapids, Mich.

Bauman's Opera Café, a popular downtown eatery, was located on Pearl Street near Ottawa Avenue. This image was captured around 1907.

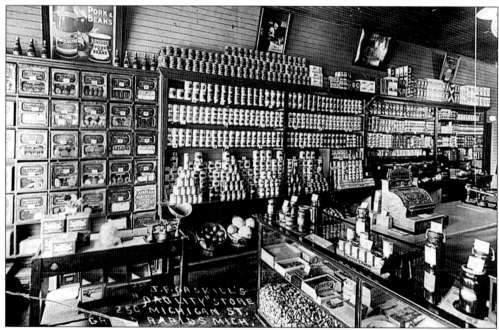

Taken around 1908, this rare, real-photo view shows the interior of the T.F. Gaskill Grocery, located on Michigan Street.

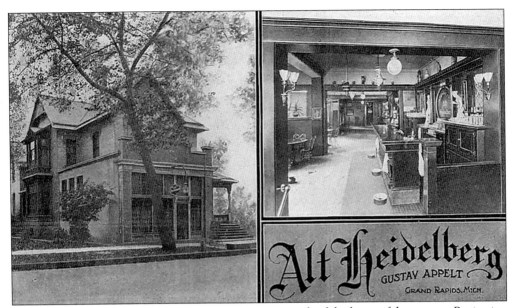

The Alt Heidelberg was located on Ottawa Avenue, north of the heart of downtown. Beginning in 1908, it was operated by Gustav Appelt as a tavern and social club, until anti-German sentiment forced its closure a decade later.

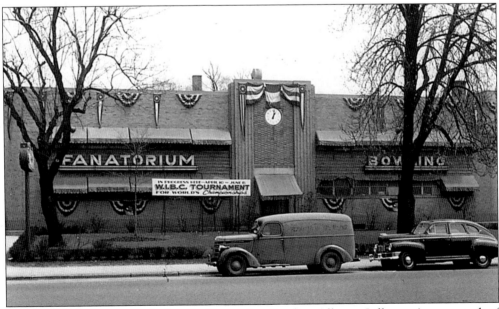

This 1938 real-photo view depicts the Fanatorium Bowling Alley on Jefferson Avenue south of Fulton Street. The building still stands, though now put to other uses.

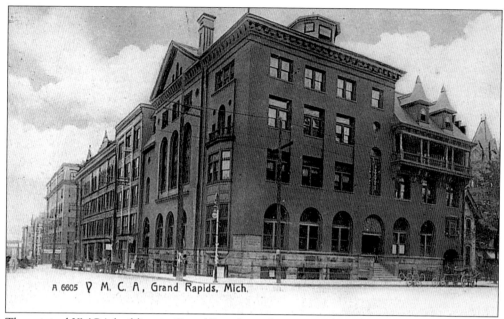

A 6605 Ρ M. C. A, Grand Rapids, Mich.

The original YMCA building in Grand Rapids, at the corner of Pearl Street and Ionia Avenue, is pictured above in 1900. On the extreme right of the photo, the tower of the city hall is visible. After the YMCA moved to other quarters in 1914, the building was converted to general office use as the Federal Square Building.

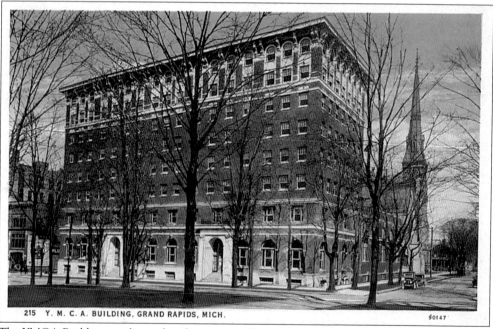

215 Y. M. C. A. BUILDING, GRAND RAPIDS, MICH.

The YMCA Building was located at the corner of Bostwick and Library Streets, as depicted in this c. 1920 image. This building was put up in 1914 to accommodate a growing demand for facilities. The original Fountain Street Church is visible on the right behind the YMCA Building.

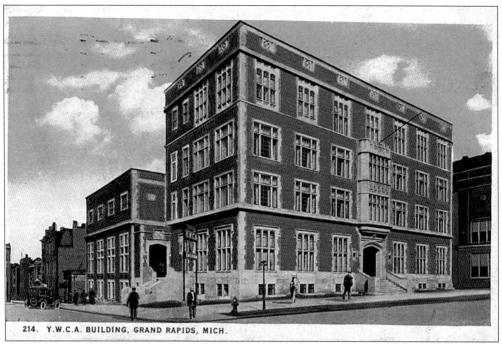

214. Y.W.C.A. BUILDING, GRAND RAPIDS, MICH.

The YWCA began in Grand Rapids in 1900, and was originally quartered in rented space on Monroe Avenue. By 1920, it was clear that a larger space was required, and this building, located on Sheldon Avenue just south of Fulton Street, was dedicated, offering athletic and social service facilities to this day.

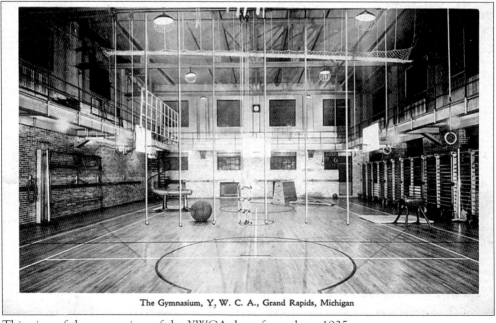

The Gymnasium, Y, W. C. A., Grand Rapids, Michigan

This view of the gymnasium of the YWCA dates from about 1925.

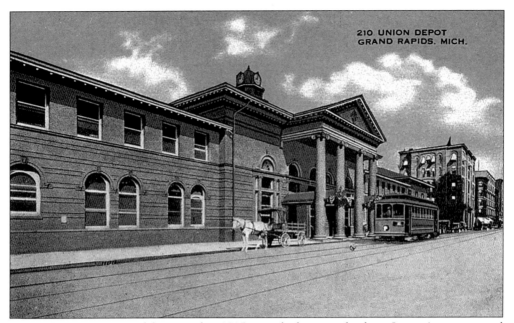

Union Station is captured here in this 1915 view looking north along Ionia Avenue toward downtown. Built in 1871, this station is located on the site just behind the present VanAndel Arena, at the heart of the Ionia Wholesale District, servicing the Grand Rapids and Indiana and Pere Marquette Railroads. It remained in use until it was removed in 1961 for freeway construction.

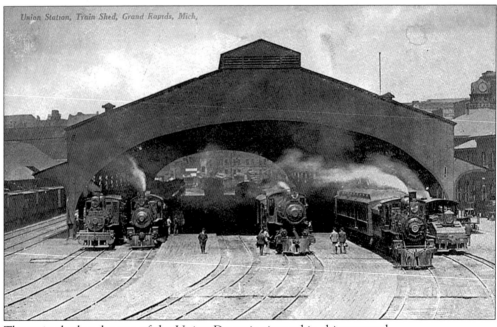

The train shed at the rear of the Union Depot is pictured in this postcard.

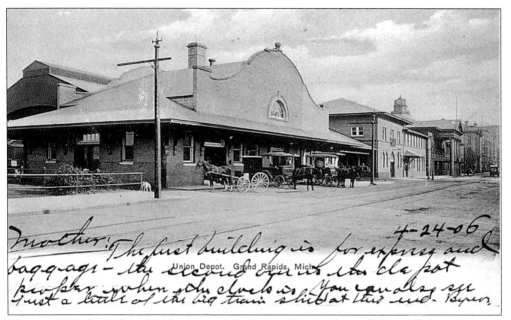

mother, The first building is for express and baggage — the second one is the depot proper when the clock is. You can also see just a little of the big train shed at this end. Byron

Union Depot. Grand Rapids, Mich.

4-24-06

This is a 1906 view of the freight depot of the Union Station, located on South Ionia Avenue. The message was written on the front of the card by necessity, as postal regulations in force until 1907 prohibited anything but an address from being put on the reverse side.

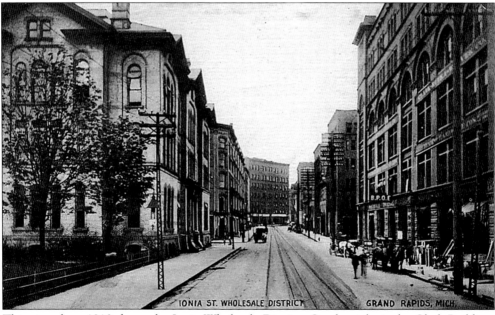

IONIA ST. WHOLESALE DISTRICT GRAND RAPIDS, MICH.

This view from 1910 shows the Ionia Wholesale District. On the right is the Clark Building, a wholesale grocery concern, and on the left is a portion of the passenger train station for the Grand Rapids and Indiana Railroad, which lies immediately off the left side of the photo. In the distance at center, the old Masonic Temple, later known as the Bishop Building, sits on the corner of Ionia Avenue and Fulton Street.

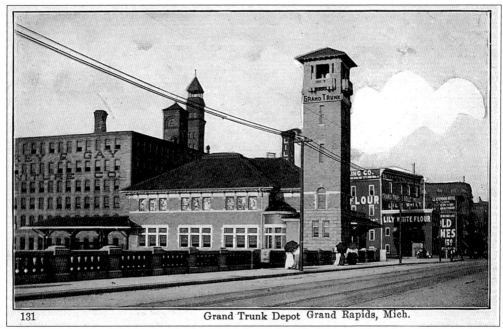

131 Grand Trunk Depot Grand Rapids, Mich.

The Grand Trunk Railroad Station, on the north side of Michigan Street at the river, was built in 1906. Immediately behind the station is the Valley City Milling Company. The station was abandoned by the railroad in 1948, and stood vacant for many years. The Valley City Mill was replaced on this site in 1923 by the Rowe Hotel.

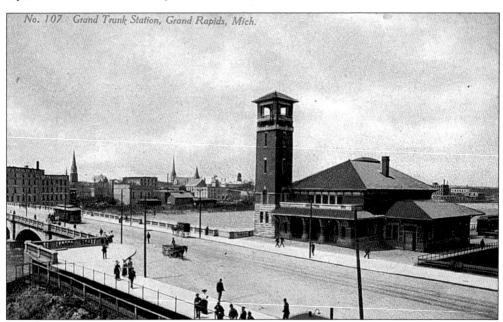

No. 107 Grand Trunk Station, Grand Rapids, Mich.

This 1908 view shows the Grand Trunk Railroad Depot on Michigan Street at the river, currently the site of the United States Post Office. This view looks northwest across the Grand River. The apparently unimproved site at the lower left corner of the photo is the present location of the DeVos Convention center.

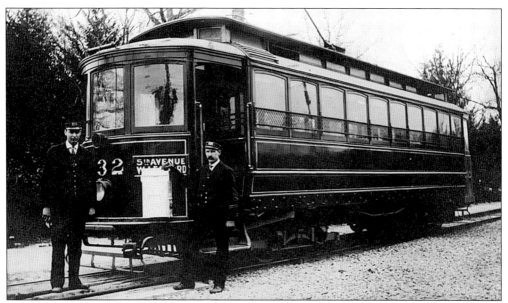

This 1910 real-photo card by the Youngs Photo Company of Grand Rapids shows an electrically driven streetcar on the Fifth Avenue/West Leonard Street Line. A mailbox is mounted on the streetcar between the motormen; this innovation by the postal service made the mailing and delivery of postcards like this one particularly fast and easy.

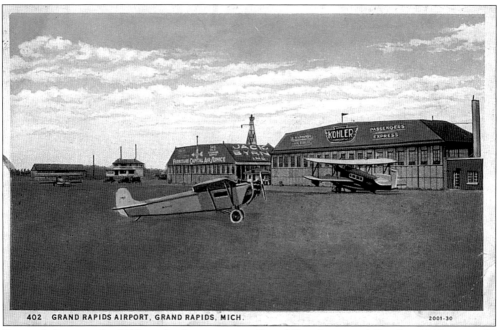

402 GRAND RAPIDS AIRPORT, GRAND RAPIDS, MICH. 2001-30

Pictured above in the 1920s is the first airport in Grand Rapids, opened October 1919 on an old farm at Madison Avenue and 32nd Street. The first commercial air service out of the airport came some nine years later in 1928, when the Kohler Air Service offered a regularly scheduled flight between Grand Rapids and Milwaukee. The airport continued in operation at this site, on an expanded basis, until 1963, when it was moved to its present location in Cascade Township.

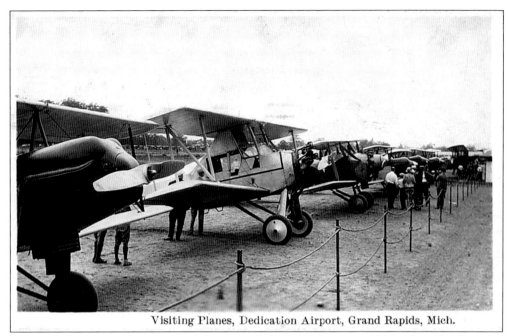

Visiting Planes, Dedication Airport, Grand Rapids, Mich.

This real-photo view depicts the dedication of the first airport in 1919, when the latest in aviation was displayed for interested locals to see.

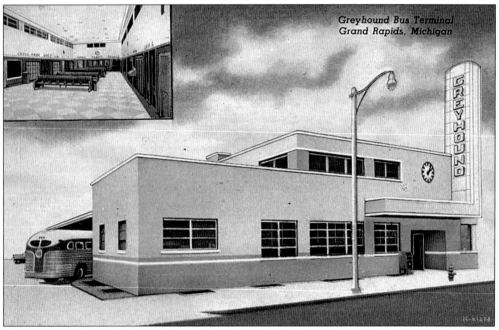

Greyhound Bus Terminal
Grand Rapids, Michigan

This is a view from about 1940 of the Greyhound Bus Terminal, located on Monroe Avenue just north of Fulton Street. The building was a contemporary design, calculated to convey the modern convenience of bus transportation. It was demolished in the 1980s.

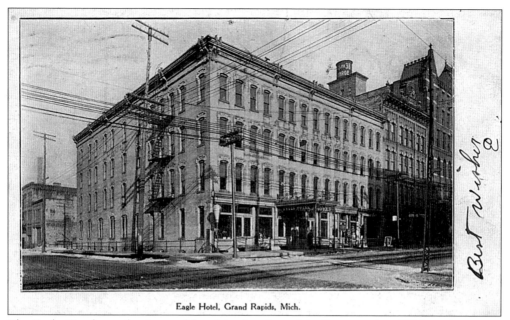

Eagle Hotel, Grand Rapids, Mich.

The Eagle Hotel was the first real hotel in the city, originally opened in 1834 on this site at Market and Louis Streets. The original structure burned in 1883, and was replaced with this building that year. This view dates from 1909.

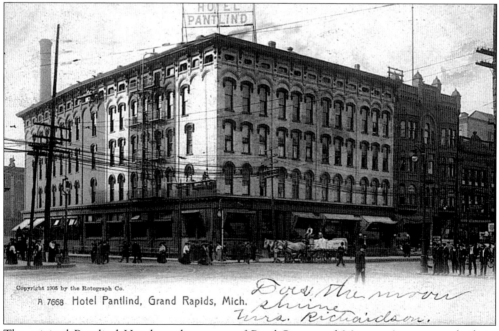

Copyright 1905 by the Rotograph Co.
A 7668 Hotel Pantlind, Grand Rapids, Mich.

The original Pantlind Hotel, at the corner of Pearl Street and Monroe Avenue was built in 1868 and operated by local miller Martin L. Sweet as Sweet's Hotel. It was taken over and renamed by J. Boyd Pantlind in 1902. This structure was replaced by the current, much larger hotel on the same site in 1916.

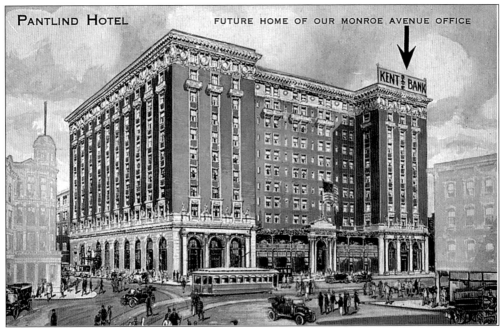

KENT STATE BANK

Pictured above is a grand promotional view of the new Pantlind Hotel for its 1916 opening. It was published by the Kent State Bank in commemoration of the bank's location in the north corner of the ground floor of the building.

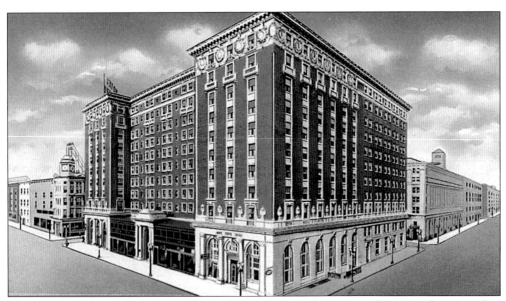

This idealized view of the new Pantlind Hotel dates from around 1935. The artist has straightened Monroe Avenue through the elimination of the curve to the southeast, at Campau Square, on the left edge of the view. Also gone is the Grand River, which would be visible on the right edge of the view, a block behind the hotel building. Such artistic license was not uncommon in postcard publishing, undertaken by a publisher for the purpose of advancing the scene most favorable to his customer.

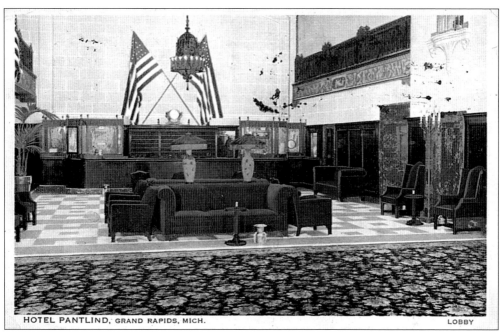

HOTEL PANTLIND, GRAND RAPIDS, MICH. LOBBY

This 1917 postcard captures a view of the Pantlind Hotel lobby.

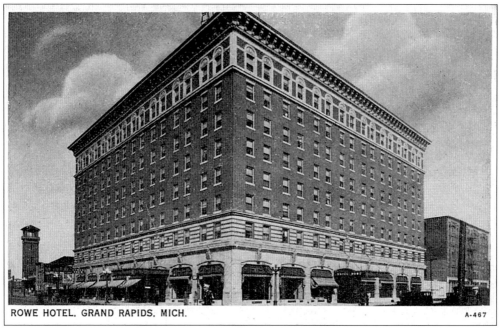

ROWE HOTEL, GRAND RAPIDS, MICH. A-467

The Rowe Hotel, at the corner of Michigan Street and Lower Monroe Avenue (Canal Street), is pictured in this *c.* 1930 photograph. To the left of the hotel building is the Grand Trunk Terminal, on the site of the present U. S. Post Office. The hotel was built in 1923 to cater to Grand Trunk passengers. In 1951, the Rowe was sold and operated under the name of the Manger-Rowe Hotel. It was converted to a retirement home in 1963, but stands vacant at present.

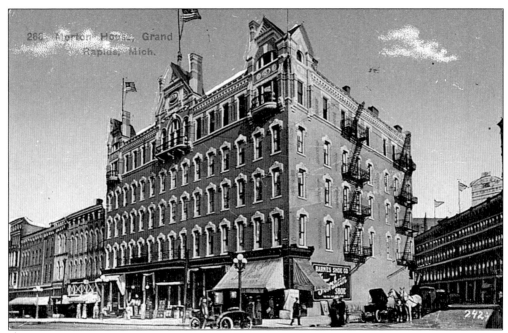

Shown above is the Morton House Hotel, on Monroe Avenue at Ionia, in a view from around 1915. This hotel, originally Hinsdill's, and later the National Hotel, opened in 1836. After a fire in 1872, the hotel was rebuilt as the Morton House. Later acquired and managed by the Pantlind Hotel Company, this structure was razed and replaced with the present building in 1923. The hotel was converted to apartments in 1970.

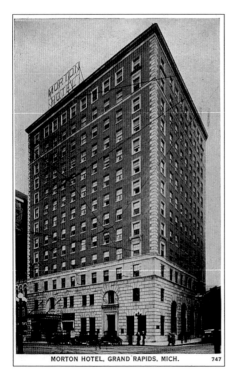

MORTON HOTEL, GRAND RAPIDS, MICH. 747

This 1935 view depicts the new Morton House Hotel, built in 1923.

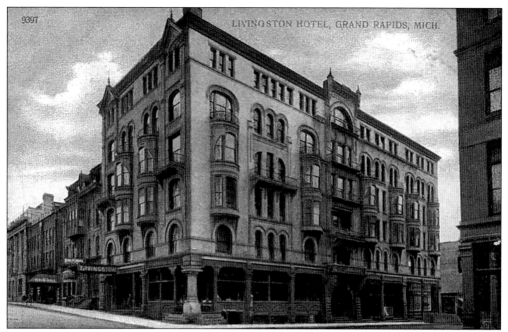

The Livingston Hotel, at the southeast corner of Fulton Street and Division Avenue, is pictured here about 1910. The first six-story building in Grand Rapids, the hotel was built in 1887, atop a foundation originally intended for a YMCA building—a plan which was abandoned at this location. It catered to traffic from the nearby Union Station until 1924, when it was destroyed in a disastrous fire in which eight people died. The site is now occupied by a building put up in 1947 as an early headquarters of Davenport College.

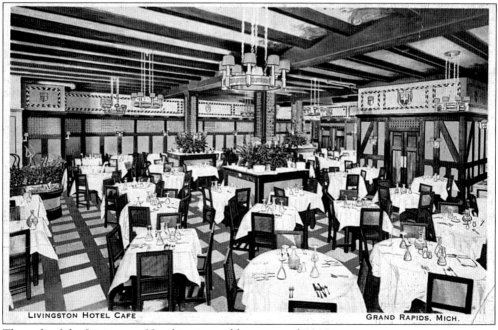

The café of the Livingston Hotel is pictured here around 1910.

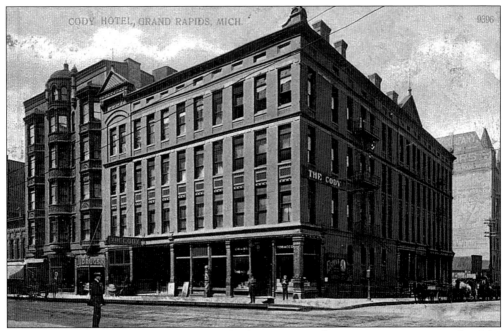

The Cody Hotel, at the southwest corner of Fulton Street and Division Avenue, across from the Livingston, is depicted here in 1908. The Cody was a full-service operation, including the Cody Cafeteria, pictured below. The hotel was built in 1886 as the Warwick, and taken over shortly thereafter by Darwin D. Cody, the first cousin of Buffalo Bill Cody. After suffering serious fire damage in 1946, the hotel was renovated. It later closed, and was torn down in 1958 for the construction of a parking ramp.

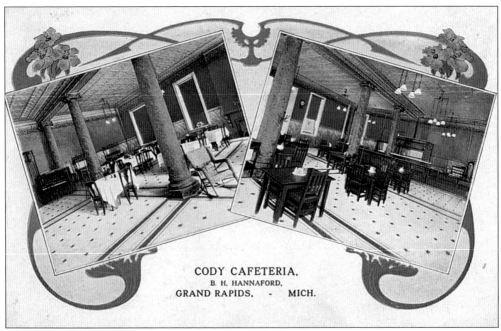

CODY CAFETERIA,
B. H. HANNAFORD,
GRAND RAPIDS, - MICH.

This 1920 view showcases the Cody Cafeteria in the Cody Hotel.

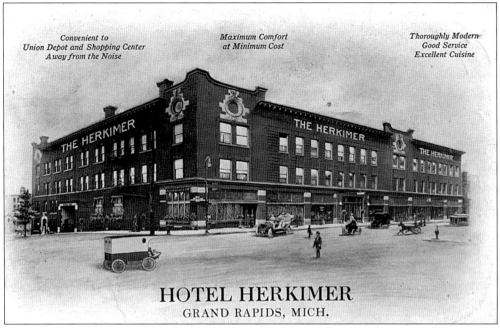

HOTEL HERKIMER
GRAND RAPIDS, MICH.

Pictured above is a 1912 view of the Hotel Herkimer, located on South Division Avenue one block east of the Union Railroad Station. Originally a temperance establishment, the hotel still operates, though since the departure of the nearby railroad station in 1962, it caters to a less-elevated clientele.

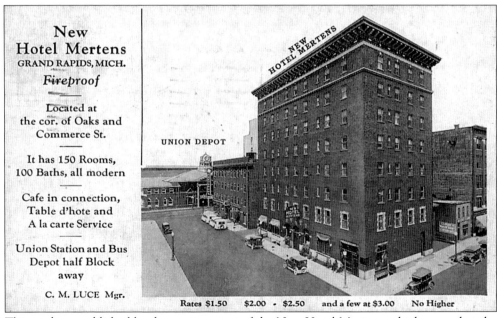

This card was published by the management of the New Hotel Mertens, which opened at the corner of Oaks and Commerce Streets in 1914.

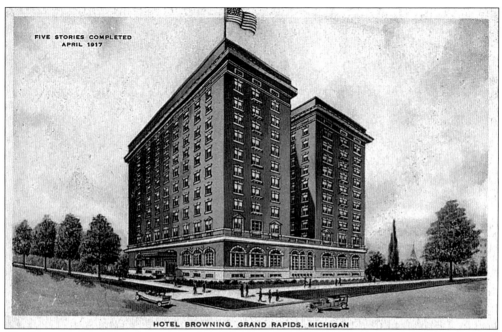

The Browning Hotel, at the corner of Sheldon Avenue and Oaks Street, is pictured here about 1920. The hotel was built in 1917 and operated until it was purchased in 1938 by the Ferguson Droste Ferguson Clinic, a private medical facility. The actual building was never as large as is depicted in the card, consisting of only five stories rather than the ten stories shown.

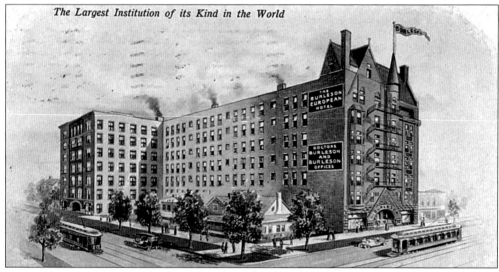

Pictured here is a commercial card produced and distributed about 1915 by the Burleson Hotel and Hospital, located at the corner of Fulton Street and Jefferson Avenue. The Burleson Hospital, a clinic for the non-surgical treatment of rectal disorders, was founded in 1899 by physician brothers Willard, John, and Fred Burleson. In the years that followed, the facility became the largest in its specialized field in the world. In 1927, the operation moved to the top floor of the Morton House Hotel, and later to a site in East Grand Rapids, where it continued in operation into the 1950s.

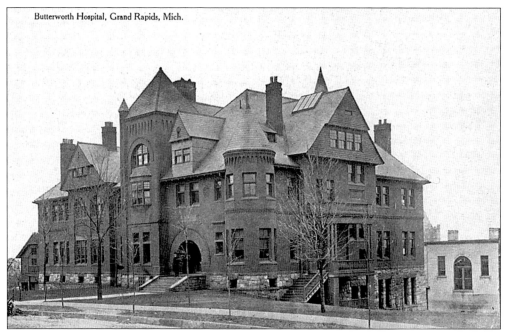

This 1910 view depicts the original building of Butterworth Hospital at the corner of Bostwick Avenue and Michigan Street. It stands on the site of the VanAndel Institute, across the street from the present hospital. The hospital traces its beginnings to 1872, when members of St. Mark's Episcopal Church opened a hospital/convalescence facility for parishioners. It was later endowed by Richard E. Butterworth (who contributed the present site) and his heirs, Mr. and Mrs. Edward Lowe. In 2000, Butterworth Hospital combined with Blodgett Hospital to become part of the Spectrum Health organization.

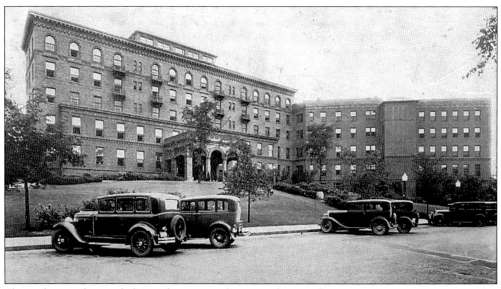

Shown here is the north front of Butterworth Hospital on Michigan Street in the late 1920s. This building is actually the core of the present, much larger facility. It was built in the early 1920s, following further gifts from Mr. and Mrs. Edward Lowe, descendants of the original benefactor.

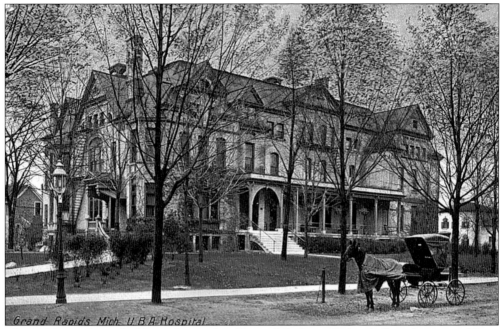

Grand Rapids Mich. U.B.A. Hospital

This 1905 view shows the Union Benevolent Hospital, built in 1886 at College Avenue and Lyon Street. This building was replaced in 1916 by the newly constructed Blodgett Memorial Hospital.

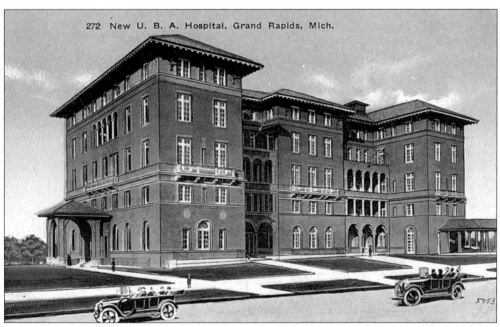

272 New U. B. A. Hospital, Grand Rapids, Mich.

The new UBA Hospital, actually Blodgett Memorial Hospital, was built in 1916. The new hospital, located on Wealthy Street in East Grand Rapids, was built and donated by local lumberman John W. Blodgett as a memorial to his mother, Jane Wood Blodgett. The hospital continues in operation at present as part of the Spectrum Health organization.

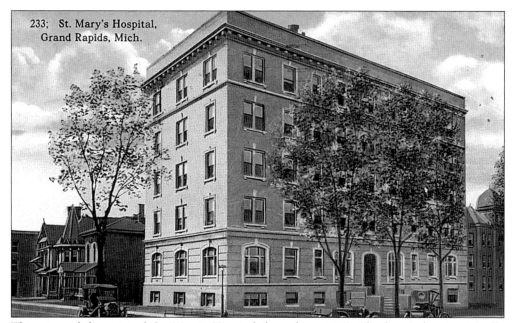

This view of the original St. Mary's Hospital dates from 1915. The hospital was originally founded in 1893. Its first structure was built in 1911 at the corner of Cherry Street and Lafayette Avenue. The hospital continued to grow, and in the process acquired additional property and built a large and modern facility that continues to serve the community.

Captured in 1915, this early real-photo view depicts the original building of St. Mary's Hospital. The house at the center of the photo was used originally as the hospital itself, and later as a residence for the Sisters of Mercy, who operated the hospital. At the left of the picture, the actual hospital building, constructed in 1911, is visible. This building, at the corner of Cherry Street and Lafayette Avenue, remained in use until 2002, when it was razed and replaced.

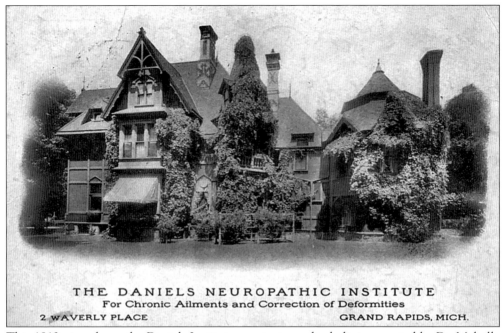

THE DANIELS NEUROPATHIC INSTITUTE
For Chronic Ailments and Correction of Deformities
2 WAVERLY PLACE GRAND RAPIDS, MICH.

This 1913 view shows the Daniels Institute, a private medical clinic operated by Dr. Melville Daniels for the treatment of (presumably) neurological disorders. The clinic was located on Waverly Place, near the corner of State Street and Jefferson Avenue.

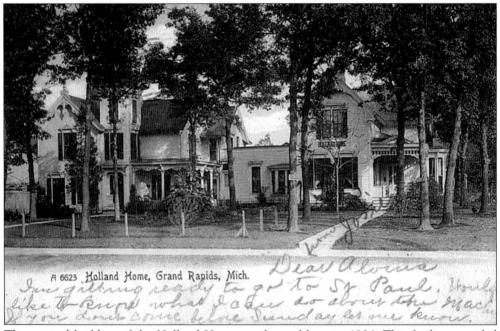

A 6623 Holland Home, Grand Rapids, Mich.

The original building of the Holland Home was located here in 1906. This facility provided convalescent and elder care services to local residents, and continues to do so today in larger and more modern facilities.

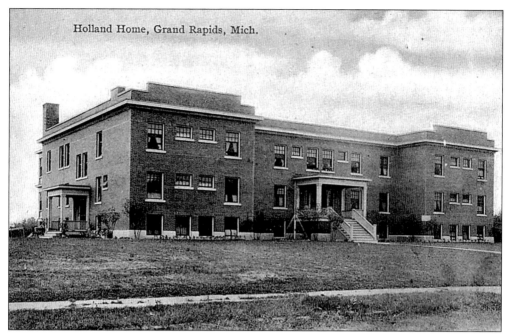

Taken in 1901, this photograph displays the Holland Home, located on Fulton Street just east of Carlton Avenue. This convalescent facility, supported by the local Christian Reformed Church, continues to operate at this and other locations in the area.

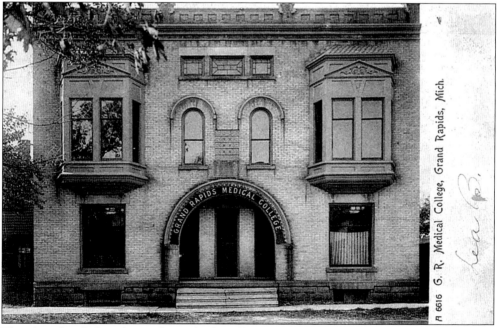

The short-lived Grand Rapids Medical College, operated sporadically by local physicians between 1897 and 1907, is depicted in this image from its final year. During its short life, the college graduated only 118 students, many of whom enjoyed successful medical careers in Grand Rapids.

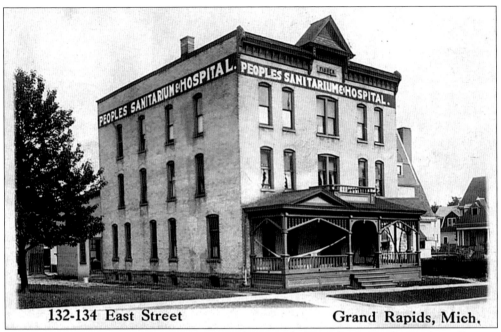

132-134 East Street Grand Rapids, Mich.

This card shows the People's Sanitarium and Hospital, located on East Street (now Eastern Avenue) from 1920. This private medical facility was part of an early health insurance plan, under which customers bought insurance coverage, and if they became ill, were housed and treated at this facility. The scheme fizzled during the depression.

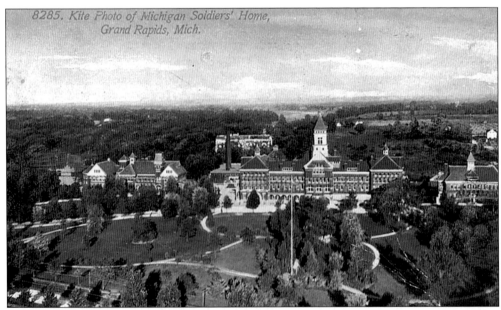

8285. Kite Photo of Michigan Soldiers' Home, Grand Rapids, Mich.

This unusual photo of the Michigan Veterans' Facility was taken in 1912 by a camera attached to a kite flown high above the Grand River. The river is visible at the lower edge of the picture. The photographer simply tripped the shutter from the ground, and then carefully reeled the kite and camera back to earth.

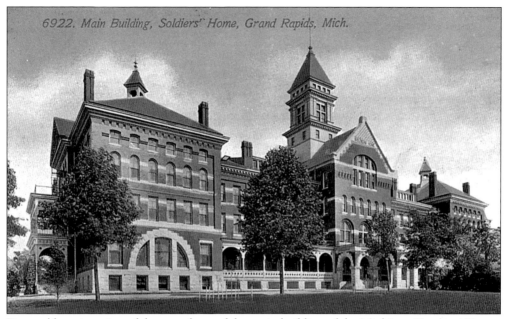

6922. Main Building, Soldiers' Home, Grand Rapids, Mich.

Pictured here is a view of the west front of the main building of the Michigan Veterans' Home, located on North Monroe Avenue. This building, one of several in the complex, was built in 1886. At the time, it was one of the first large-scale veterans' facilities in the country. The home provided hospital and convalescent services for veterans of the Civil War, Spanish American War, and later wars. It also attended to their spouses. Though now in vastly updated facilities, the home continues to operate on this site today.

Built in 1937, the Burleson Clinic continued to operate into the 1950s. It stood on Greenwood Avenue, just west of Reeds Lake in East Grand Rapids.

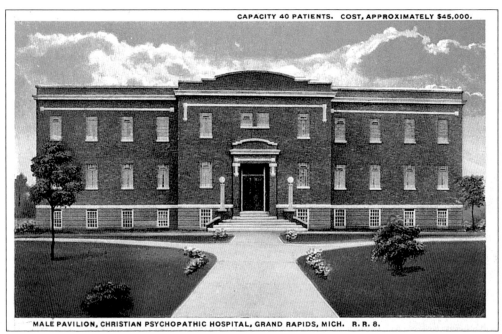

This 1927 view shows the original building of Pine Rest Christian Hospital, located on Division Avenue south of Grand Rapids. The hospital, dedicated to the treatment of mental illness, was founded in 1910; its first building was constructed in the decade which followed.

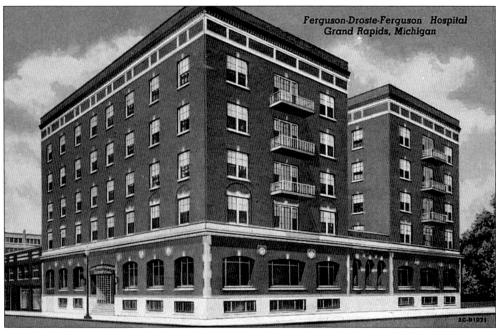

Ferguson-Droste-Ferguson Hospital
Grand Rapids, Michigan

The Ferguson Droste Ferguson Hospital, was originally organized in 1929. It moved to this site, the former Browning Hotel on Sheldon Street south of Fulton Street, in 1938. The hospital became internationally renowned for treatment of colon and rectal diseases, and eventually merged with the Blodgett Hospital.

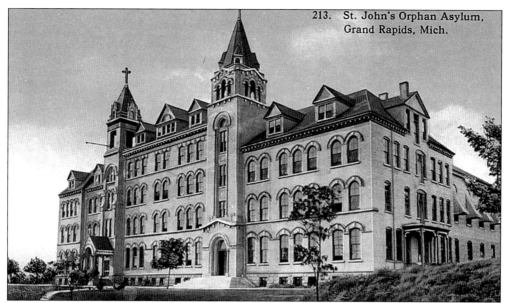

Shown here in 1912, the St. John's Home was the mother house of the Dominican Sisters in Grand Rapids. The building was constructed in 1889 on East Leonard Street, east of downtown. It continued to operate as an orphanage until it was torn down and replaced in 1960.

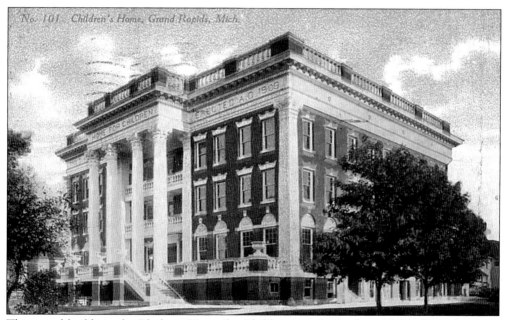

No. 101 Children's Home, Grand Rapids, Mich.

This grand building, the Blodgett Home for Children, was located on Cherry Street between Diamond and Eastern Avenues. It was constructed as an orphanage by lumberman Delos A. Blodgett, the father of Blodgett Hospital's benefactor. The organization was essentially a privately-funded foundling and social service agency, which continues to operate today at a different location. This building was subsequently occupied by the Mary Free Bed Hospital, which added to the front of the structure, obscuring the original appearance to all but the most attentive observer. It is presently home to the Abney Academy. This view is from 1911.

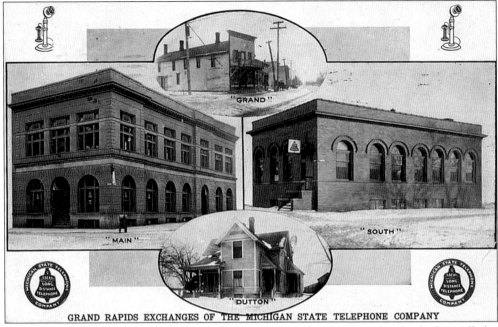

GRAND RAPIDS EXCHANGES OF THE MICHIGAN STATE TELEPHONE COMPANY

This card was used in 1910 by a local dentist to notify his patients that he had installed a Michigan State (Bell) telephone at his office. Issued by the telephone company, it depicts the various locations of the phone company in the Grand Rapids area. The building at the right still stands on Hall Street at Madison Square; the building on the left is downtown, on Louis Street.

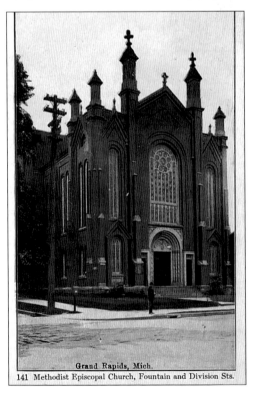

Grand Rapids, Mich.
141 Methodist Episcopal Church, Fountain and Division Sts.

Shown here around 1908, the First Methodist Church stood at the corner of Division Avenue and Fountain Street. The congregation built and moved to a larger church, on Fulton Street and Barclay Avenue, in 1912. This building was taken down and replaced by the Keeler Building that year.

Fountain Street Church traces its beginnings to a Baptist mission founded on the banks of the Grand River in 1837. The church itself was founded in 1842. This Gothic Revival building was built in 1896 at the corner of Fountain Street and Bostwick Avenue on the eastern edge of downtown. A catastrophic fire in 1917 totally destroyed the building, which was replaced eight years later by the Italian Romanesque structure which continues in use today. Over the decades since its founding, Fountain Street Church has pulled away from its Baptist beginnings and flourishes today as a large, liberal-non-sectarian congregation.

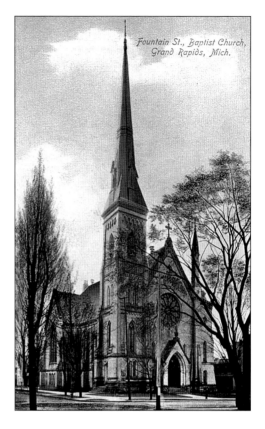

Milton
M.
McGorrill
Minister

This view of Fountain Street Church, on the same site as its predecessor, dates from 1933, shortly after the completion of the new church building, in 1925.

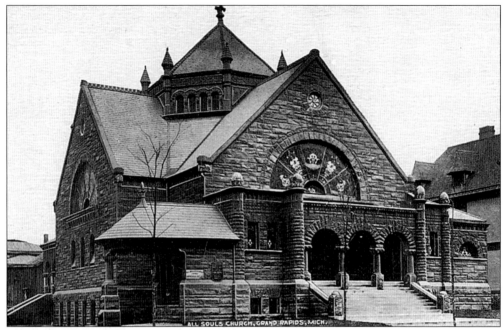

Show above is a 1908 view of the All Souls Universalist Church on Sheldon Avenue south of Fulton Street. The church was built in 1892 to the design of local architect W.G. Robinson; the congregation remains active and the building largely unaltered today.

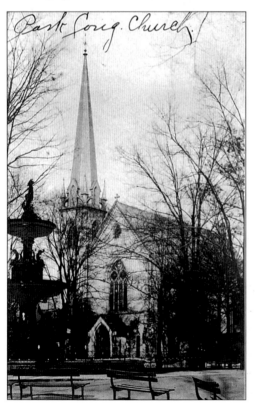

Dating from about 1888, this early real-photo card depicts the Park Congregational Church at the corner of Library Street and Park Avenue. In the foreground is the fountain in Fulton Street Park (later Veterans' Memorial Park), across the street from the church. The Gothic spire on the church, removed in 1890 when it began to lean dangerously, is visible here.

This later view of Park Church dates from about 1925. The congregation, which began in 1836, built its church on this site in 1867. The building featured a tall Gothic spire, the lower half of which remains today. In 1929, an enlargement and renovation of the church was undertaken, adding to the size of the building and creating its present appearance.

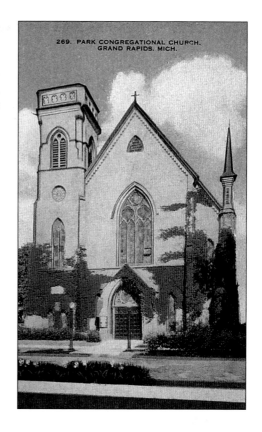

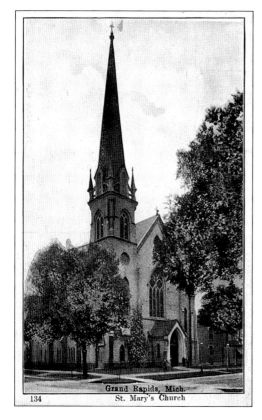

Pictured here is St. Mary's Catholic Church on First Street, on the city's west side. This is an old building, constructed in 1874. The view is from 1925.

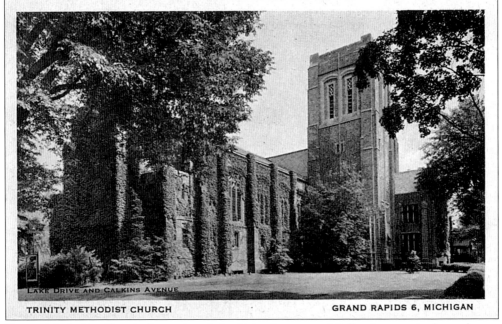

TRINITY METHODIST CHURCH GRAND RAPIDS 6, MICHIGAN

Trinity Methodist Church, located on Lake Drive just west of Fuller Avenue, is shown here a few years after its construction in 1922.

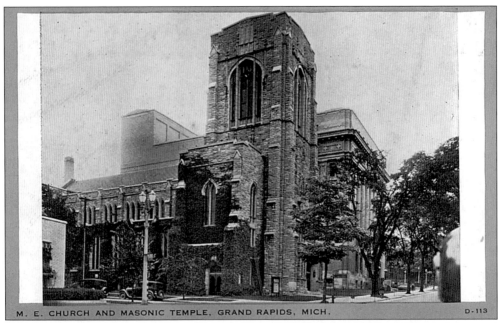

M. E. CHURCH AND MASONIC TEMPLE, GRAND RAPIDS, MICH. D-113

Captured in 1930, this view shows the First United Methodist Church at Fulton Street and Barclay Avenue. This church was built to replace the earlier building located at Division and Fountain Street; it opened in 1916. Immediately to the east of the church is the Masonic Temple building.

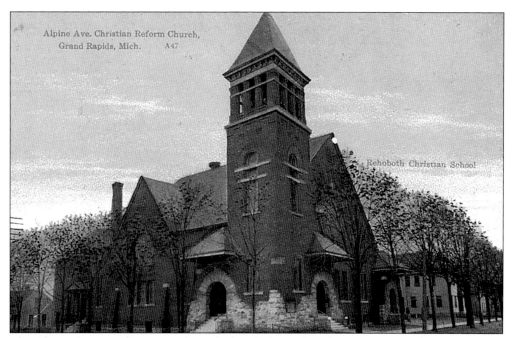

The Alpine Avenue Christian Reformed Church, located on the west side of the city, is pictured here in 1910. This building was constructed in 1904. The congregation relocated in 1990, when it merged with another church to become the Westend Christian Reformed Church.

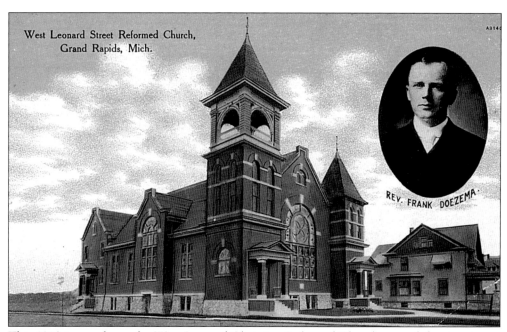

This 1912 image shows the West Leonard Christian Reformed Church around the time it was built, located on the west side of the city.

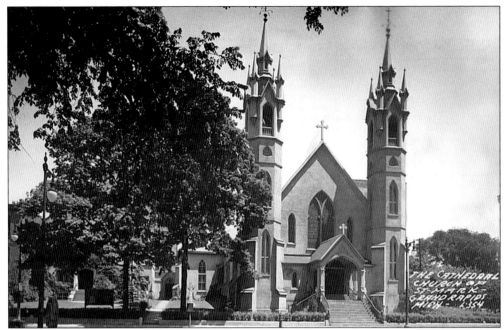

St. Mark's Episcopal Church, on Division Avenue at Pearl Street, is pictured here about 1935. This congregation, one of the oldest in Grand Rapids, was founded in 1836. The church building was constructed in 1848, making use of stone dredged from the Grand River. The twin towers were added to the original church building in 1851. Shortly after construction, a layer of stucco was applied to the stone church and towers—it was thought necessary to protect the stone construction—but was ultimately removed in 1957, revealing its present facade.

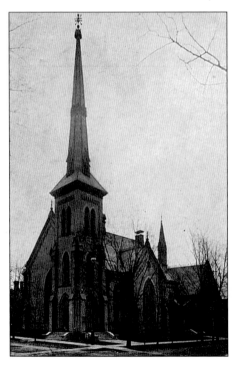

The Westminster Presbyterian Church at the corner of Weston Street and LaGrave Avenue is pictured here in 1905. This church, the founding Presbyterian congregation in Grand Rapids, was built in between 1867 and 1874.

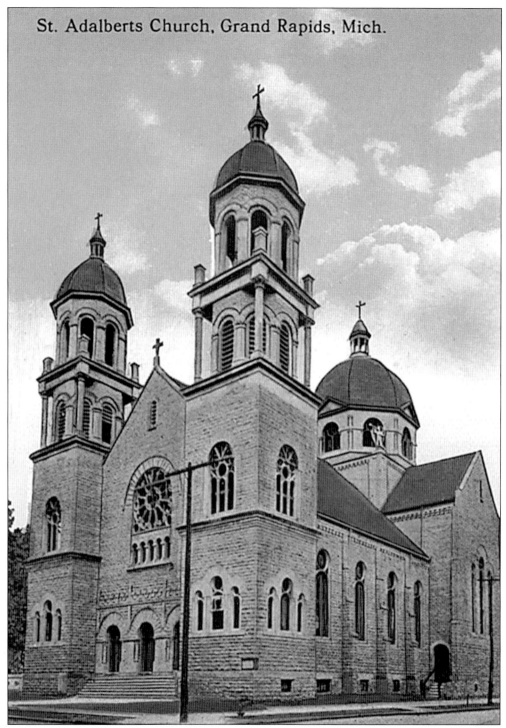

St. Adalberts Church, Grand Rapids, Mich.

St Adalbert's Basilica, on Davis Avenue on the west side of the city, was built 1913, based on a design distinctly different from other churches of that era. It was probably constructed in conformity with the European roots of its largely immigrant congregation.

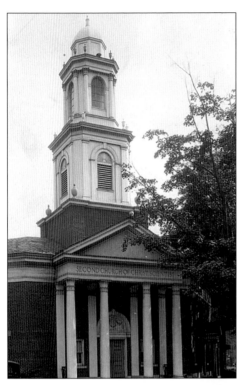

Shown here around 1930 is the First Pilgrim Tabernacle Church at the southeast corner of Fountain and Bostwick Streets. This building was purchased as an annex by the Grand Rapids Public Library, and later demolished in 1966 for the construction of the present library on the site.

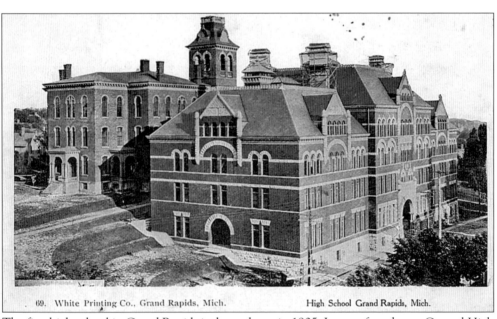

69. White Printing Co., Grand Rapids, Mich. High School Grand Rapids, Mich.

The first high school in Grand Rapids is shown here, in 1905. Later referred to as Central High School, it was located on the crest of the hill east of the city, on Ransom Street south of Lyon Street. The building at the left, the original school building, was constructed in 1899. The more recent building, to the right, was used into the early 1970s, and then replaced by several buildings of the Grand Rapids Community College.

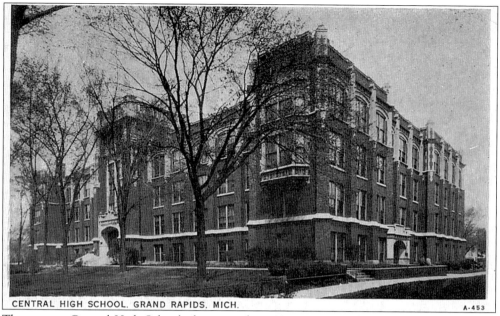

CENTRAL HIGH SCHOOL. GRAND RAPIDS. MICH. A-453

The present Central High School, shown in this 1930 image, was built in 1910 on Fountain Street between Lafayette and College Avenues.

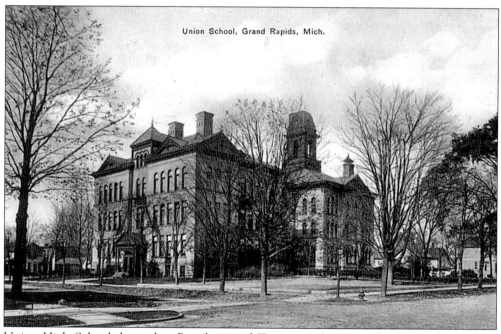

Union School, Grand Rapids, Mich.

Union High School, located at Broadway and Turner on the west side of Grand Rapids, is pictured here in 1900. This was the first "graded" high school in the city.

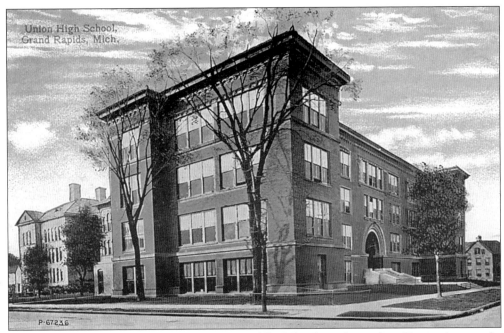

The second Union High School, now West Middle School was located on Turner Avenue. In this 1913 card, the original high school building is visible at the left edge of the picture. The high school moved to its present location in the late 1960s.

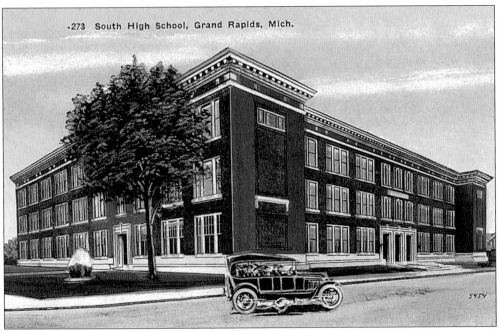

This 1925 view shows South High School, located at the intersection of Jefferson Avenue and Hall Street. Built in 1915, South was one of four Grand Rapids high schools for many years, and counted President Gerald R. Ford among its graduates. It was closed in the late 1960s.

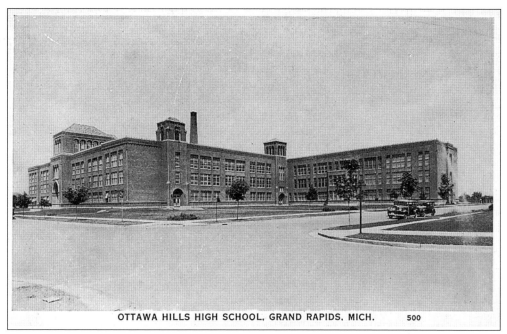

OTTAWA HILLS HIGH SCHOOL, GRAND RAPIDS, MICH. 500

Ottawa Hill High School, at the corner of Iroquois Avenue and Fisk Street, is shown here around 1930. This was shortly after its construction in 1925, and the later addition of the elementary school wing, visible on the right side of the picture.

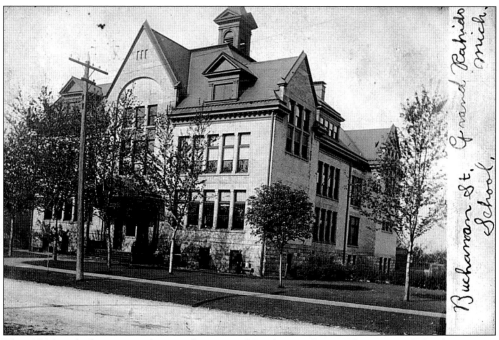

This 1910 real-photo view depicts the original Buchanan Street Elementary School.

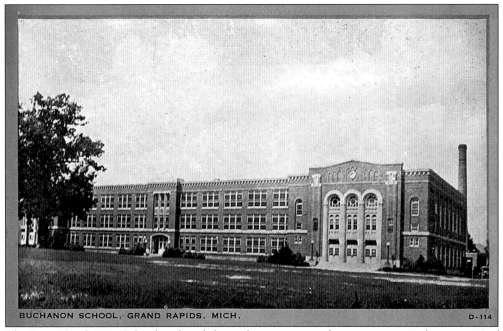

The "new" Buchanan School replaced the earlier structure a few years prior to the creation of this 1938 postcard.

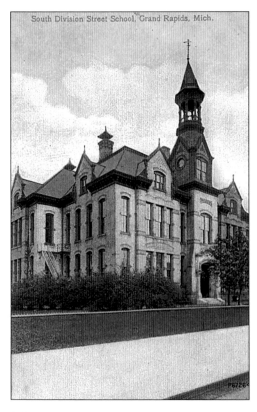

Dating from 1910, this postcard shows the South Division Street School.

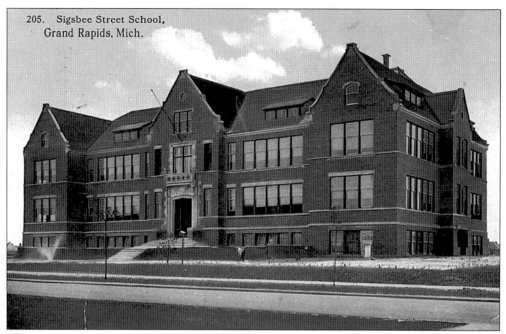

205. Sigsbee Street School, Grand Rapids, Mich.

The original Sigsbee Street school is pictured here in 1918. Built in 1910, the street and school were named for the commander of the ill-fated battleship *Maine*, the early focus of the Spanish-American War. This building, a Dutch Colonial style befitting the predominant nationality of the neighborhood, continued in use until the 1980s, when it was razed and replaced with a new building on the same site.

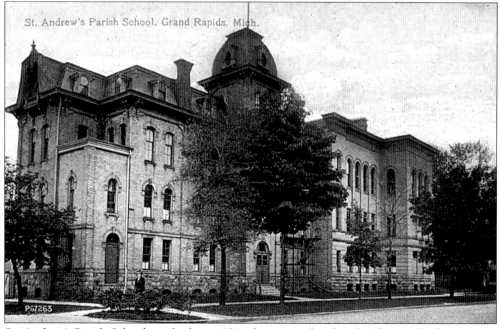

St. Andrew's Parish School, Grand Rapids, Mich.

P67263

St. Andrew's Parish School was built in 1874 adjacent to the church. This card is from 1910.

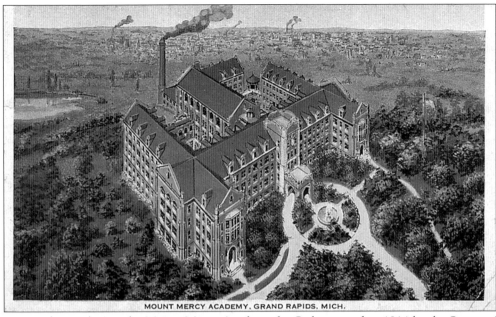

MOUNT MERCY ACADEMY, GRAND RAPIDS, MICH.

An aerial view depicts the Mount Mercy Academy for Girls, opened in 1914 by the Sisters of Mercy. This postcard dates from about 1925.

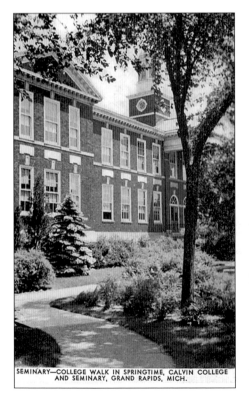

SEMINARY—COLLEGE WALK IN SPRINGTIME, CALVIN COLLEGE AND SEMINARY, GRAND RAPIDS, MICH.

The main building of Calvin College was located on Franklin Street between Benjamin and Giddings Avenues. The college was originally founded as an arm of the Christian Reformed Church in 1876. It expanded on this site to cover the entire city block, and eventually moved its campus to a larger site at the corner of Burton Street and the East Belt Line in the late 1960s. The Grand Rapids Public Schools presently occupy this location. This postcard dates from 1930.

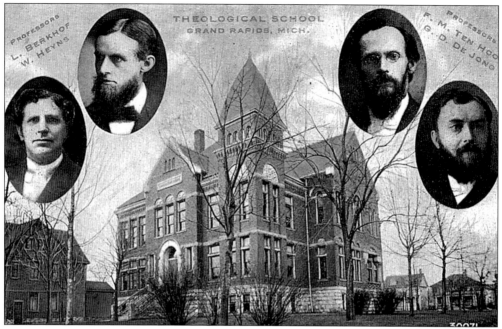

This card from around 1912 captures the faculty and building of the Grand Rapids Theological School, which was opened in 1876. This building was located at the corner of Madison Avenue and Franklin Street.

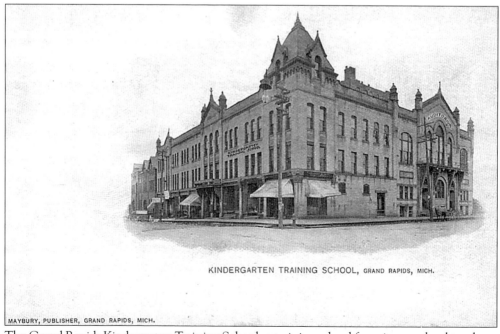

The Grand Rapids Kindergarten Training School, a training school for primary school teachers, was located at 173 South Lafayette Avenue when this picture was taken in 1900.

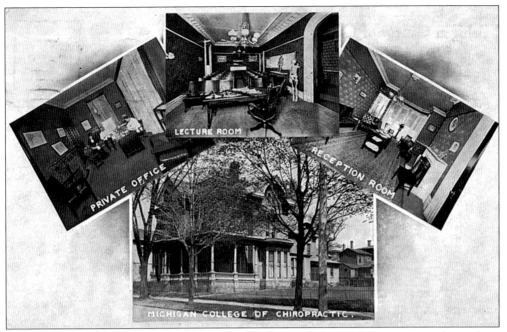

LECTURE ROOM

PRIVATE OFFICE

RECEPTION ROOM

MICHIGAN COLLEGE OF CHIROPRACTIC.

This composite card from 1912 depicts the Michigan College of Chiropractic, located on Jefferson Avenue near the intersection of Cherry Street. The college was started by M.B. Thompson, D.C., in 1908, and quickly grew to be the largest college of chiropractic medicine east of the Mississippi River. It moved into these quarters in 1912.

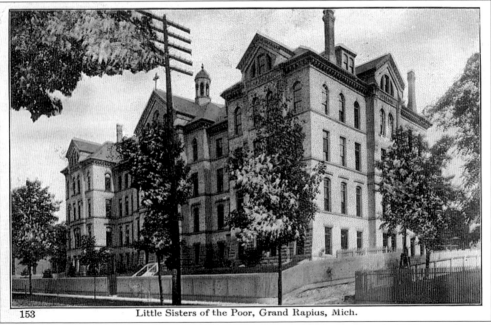

153 Little Sisters of the Poor, Grand Rapius, Mich.

The building of the Little Sisters of the Poor, pictured here around 1911, was located immediately east of St. Mary's Hospital on Lafayette Avenue. This was a convalescent facility which operated until the early 1970s, when it was demolished for hospital expansion.

104

The Civil War Memorial is located in Monument Park, in the center of the city at the intersection of Fulton Street and Division Avenue. The 34-foot-tall monument, which memorializes Civil War battles in which local troops fought, was dedicated at the local reunion of the Veterans of the Grand Army of the Republic in September 1885. The monument was restored and refurbished in 2004. This postcard is from 1910.

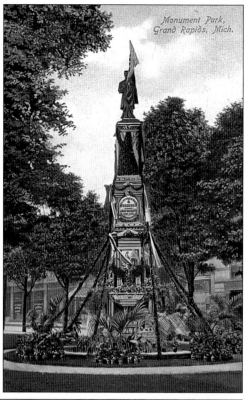

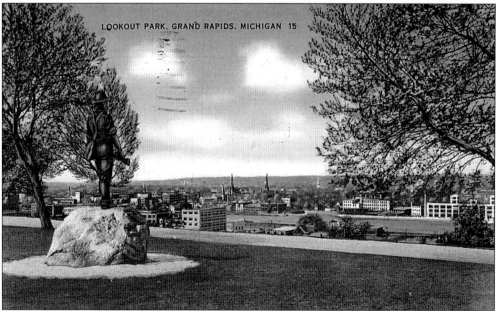

Lookout Park, located on the bluff north and east of downtown, has changed considerably since this view from 1930. The statue pictured honors Spanish-American War Veterans, and has been relocated to a park at State and Cherry Streets. In the 1960s, more than two million yards of sand were excavated and removed from the park for local expressway construction.

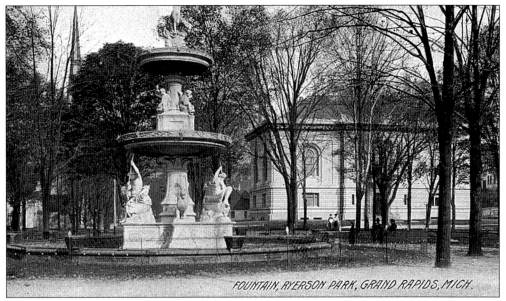

FOUNTAIN, RYERSON PARK, GRAND RAPIDS, MICH.

This view shows the ornate fountain in "Ryerson Park," actually Fulton Street Park, now known as Veterans' Park, on Fulton Street. In this photo from 1905, the new Ryerson Library is seen on the right side, with the Gothic steeple of the old Fountain Street Church visible on the left side. This park was the original location of the first Kent County Courthouse, built in 1838. After that building burned in 1844, the courthouse was relocated, and this site was dedicated as a park.

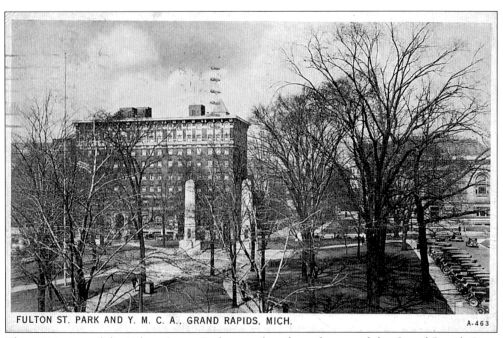

FULTON ST. PARK AND Y. M. C. A., GRAND RAPIDS. MICH. A-463

This 1930 view of the Fulton Street Park was taken from the top of the Grand Rapids Press building across the street. The Veterans' Memorial, added to the park after World War I, has replaced the original fountain. Beyond, the YMCA Building is visible.

106

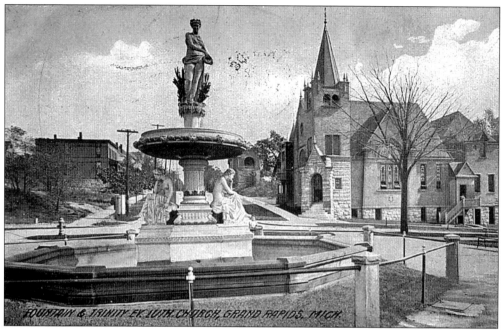

FOUNTAIN & TRINITY EV. LUTH. CHURCH, GRAND RAPIDS, MICH.

The fountain in tiny Crescent Park, located at the intersection of Crescent Street and Bostwick Avenue near Butterworth Hospital, is shown here in 1909. The park is still there, though the 1883 fountain was removed in 1949.

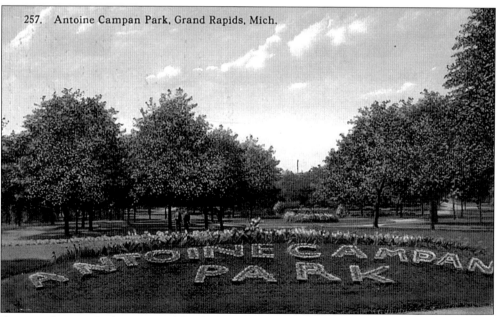

257. Antoine Campan Park, Grand Rapids, Mich.

Antoine Campau Park was named for the brother of Grand Rapids' founder, Louis Campau. It is located at Division Avenue and Antoine Street, as shown in this c. 1915 image. The park was given to the city by Martin Ryerson, a Campau descendant, in 1899. The land was originally part of the Antoine Campau farm, and is now the site of public housing.

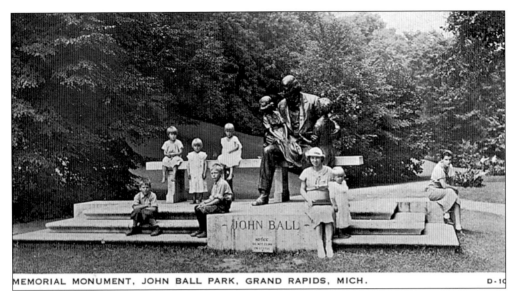

MEMORIAL MONUMENT, JOHN BALL PARK, GRAND RAPIDS, MICH. D-1C

Pictured above is a view of the memorial sculpture of John Ball, located just outside the entrance to the Zoological Garden at John Ball Park, at the extreme west end of Fulton Street. Most of the land upon which the park sits was given to the city by early resident John Ball. The statue group includes the local pioneer, as well as two of his great-grandchildren, John Ball III and Virginia Ball. The sculpture is actually the second memorial on the site; the first, consisting of a carved bust of wood, was replaced in 1925 with this bronze group by Italian sculptor, Pompeo Coppini.

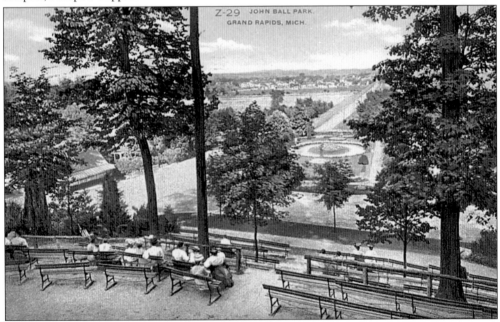

Captured in 1910, this view was taken from the heights of John Ball Park. The 150-acre park was created on land donated to the city in 1869 by John Ball. Since that time, it has been the focus of a garden and wildlife display, including a zoo. In this view, looking east from the park, the city is visible in the distance.

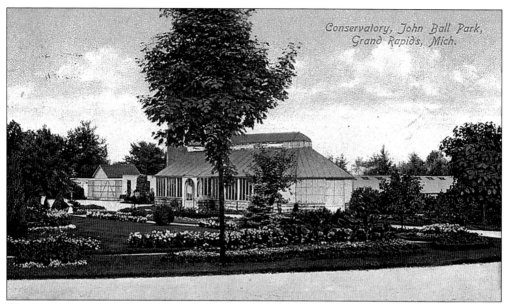

This 1908 view shows a conservatory formerly located in John Ball Park, housing exotic plants for viewing by the public. Behind the conservatory stands a series of greenhouses operated by the City to provide planting stock for the many elaborate park gardens located throughout Grand Rapids. The conservatory and greenhouses later fell into disuse and were removed.

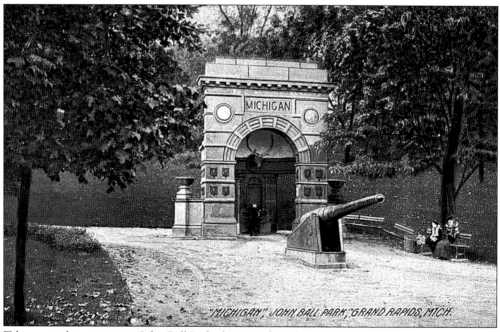

Taken near the entrance to John Ball Park, this view dates from 1908. The cannon, presented to the City by President McKinley, was captured from a Spanish warship during the Spanish-American War. The archway appeared originally in a display at the 1893 Columbian Exposition in Chicago; it was constructed of and exhibited various mineral resources from the State of Michigan.

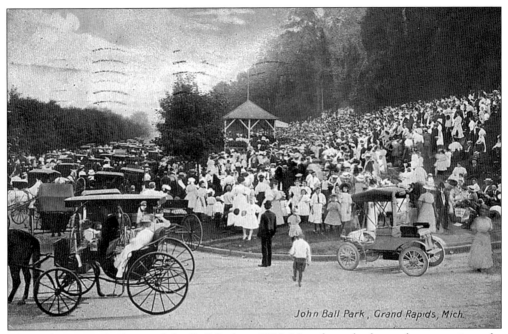

This gathering took place in John Ball Park in 1910. Note how the horse-drawn carriages far outnumber the single motored vehicle at the right.

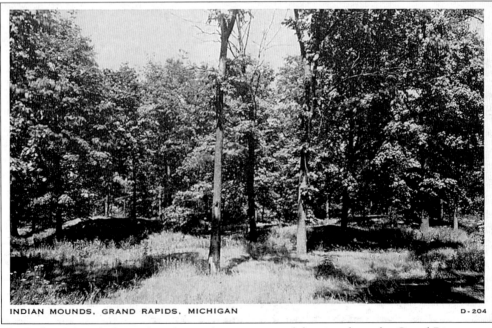

INDIAN MOUNDS, GRAND RAPIDS, MICHIGAN D-204

The Indian Mounds, located in the southwest corner of the city along the Grand River, are a protected burial site of the pre-historic Hopewell Indians. This view is from around 1935.

201. City Market, Grand Rapids, Mich.

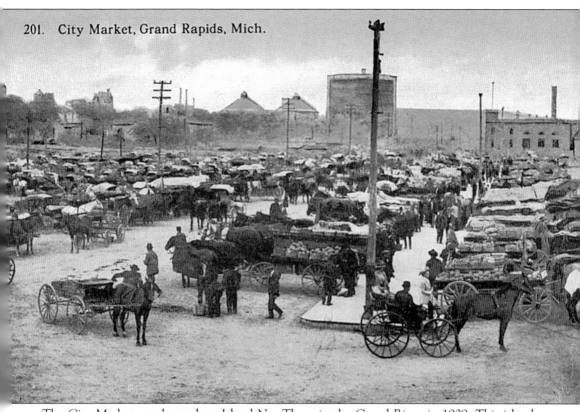

The City Market was located on Island No. Three in the Grand River in 1909. This island, between Fulton and Wealthy Streets, was long ago incorporated into the eastern bank of the river. The printed message on the back of the card describes the market as the largest fresh-produce market in Michigan, selling as many as 60,000 bushels of peaches in a single morning.

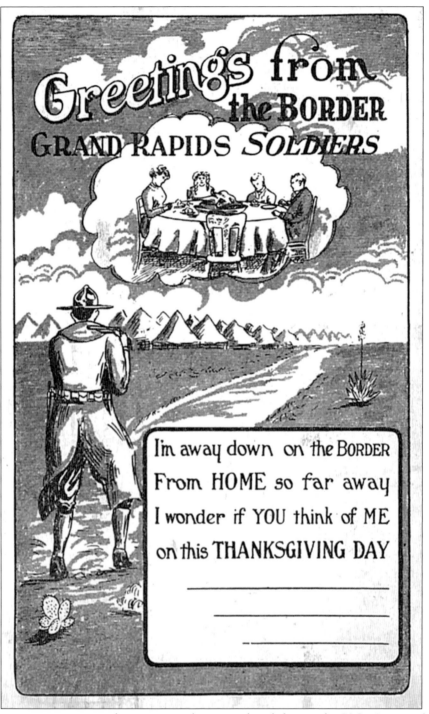

This interesting, pre-printed greeting card was produced for use by U.S. Army inductees undergoing basic training in Texas just before the entry of the United States into World War I. The message on the card, addressed to Miss Angelina Brownwell, from Louis, asks why she never writes to him, and requests her to write soon and to "send me something to eat."

Three

THE CITY AT WORK

From its very beginnings, the City of Grand Rapids has been a center of wholesale, retail, and manufacturing enterprise. Early on, much of this business activity focused directly or indirectly on the manufacture and sale of the furniture for which Grand Rapids became internationally famous. Other industries developed also, however, and contribute today to a broad manufacturing base.

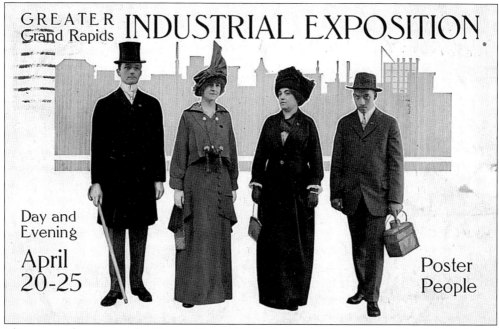

This postcard promotes the Greater Grand Rapids Industrial Exposition of April 1914. It was one of many such attractions which were created and promoted during the opening decades of the 20th century in Grand Rapids. The obvious purpose of the photos of "residents" on the card is to portray Grand Rapids as not only a manufacturing center, but also a residential and cultural community of increasing size and sophistication.

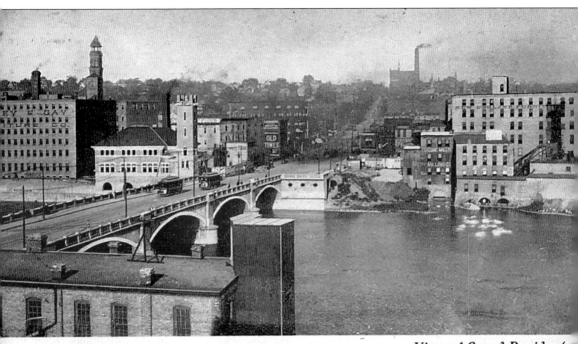

View of Grand Rapids sh...

This double card, folded at the center for mailing, dates from 1908 and shows the entire eastern bank of the Grand River from the Bridge Street Bridge south to Pearl Street. The caption on

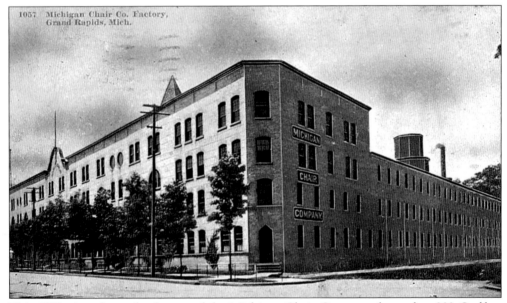

1057 Michigan Chair Co. Factory, Grand Rapids, Mich.

This 1912 view shows the factory of the Michigan Chair Company, located at 803 Godfrey Avenue. The company operated at this location, producing a huge variety of wooden chairs, until it closed in 1939.

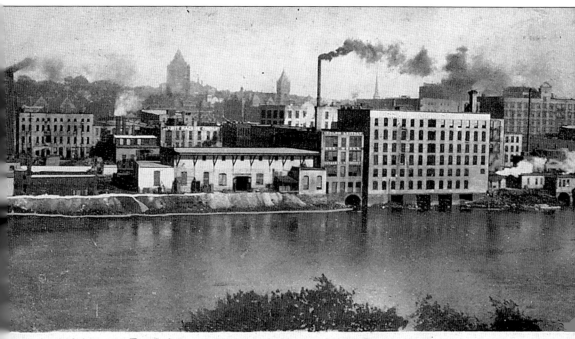

the card identifies the buildings, all of them now gone. The DeVos Convention Center now occupies most of this site.

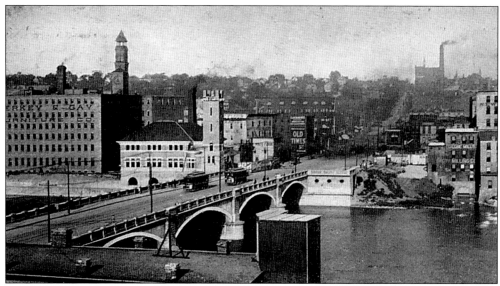

Pictured here is the Imperial Furniture Company in 1910. The factory was built in 1905 and manufactured high-quality tables for nearly 50 years. Company founder F. Stuart Foote is believed to have invented the term "coffee table," and was the first manufacturer of Duncan Phyfe reproduction furniture. In 1954, Imperial was sold to the Bergsma Brothers Company.

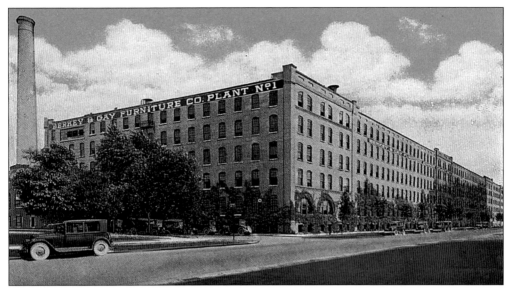

The Berkey and Gay Furniture Company was located on North Monroe Avenue, as seen in this 1925 image. The building, which remains today, is actually the same factory depicted in the postcard below (then the Oriel Furniture Company). It has been much enlarged and is viewed here from the north. Berkey and Gay, the most prominent name in the early Grand Rapids furniture boom, was founded in 1873, and continued to grow and prosper until 1929, when it was acquired by the Simmons Company of Chicago. The company closed in 1948.

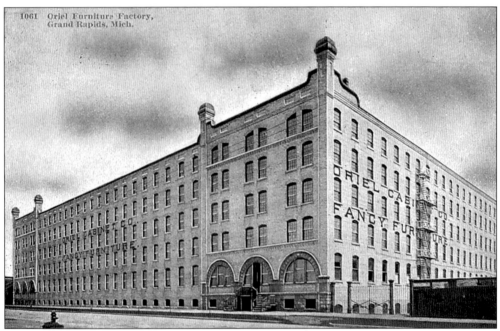

As shown in this 1910 image, the Oriel Furniture Company, one of the largest furniture manufactories in the city, was located on North Monroe. This was actually the company's second home, built in 1893. Oriel manufactured a variety of home furnishings in the Victorian and Eastlake styles. The company merged with Berkey and Gay in 1912.

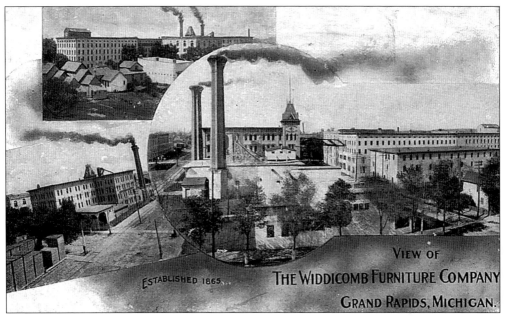

This 1910 composite view depicts the Widdicomb Furniture Company factories, located on Summer Street on the near west side of Grand Rapids.

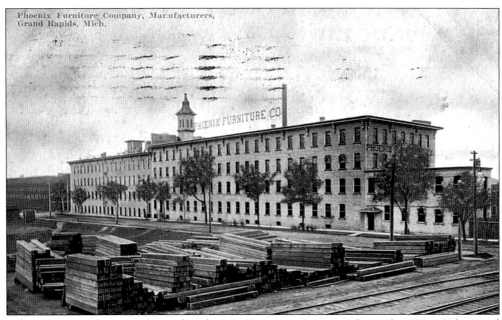

Taken in 1911, this view shows the Phoenix Furniture Company, located at West Fulton and Summer Streets. Phoenix was a manufacturer of high-grade household furniture. The company was founded by William Berkey in 1870, and this factory was built between 1873 and 1875. The company prospered until 1911, when it was incorporated into the Robert W. Irwin Company, which continued to operate until 1953. In the late 1950s, this factory building became the home of the Stow-Davis Furniture Company. Though it was torn down in 1988, a portion of the factory and its contents were preserved and reconstructed in the Grand Rapids Public Museum.

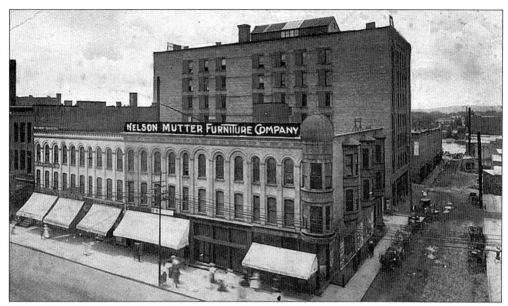

The Nelson Matter Furniture Company was located downtown on Monroe Avenue, on the site of the present DeVos Hall. These buildings were constructed in 1873 and housed not only manufacturing, but also the company offices and retail sales rooms. Nelson Matter operated successfully for many years after its founding, making and selling high-quality home furnishings. It was also a major hotel furniture supplier, until the financial stresses of World War I forced its closing in 1917. Note the misspelling of the name on the retouched company sign. This postcard dates from 1925.

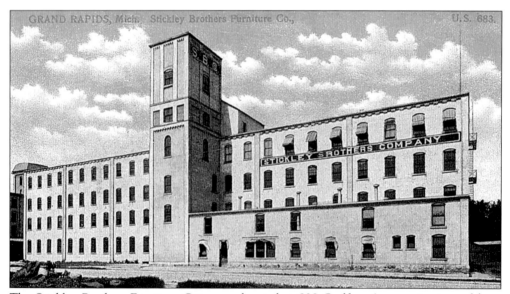

The Stickley Brothers Furniture Company, located at 838 Godfrey Avenue, is pictured here around 1910. The business was founded by Albert and John Stickley, brothers of Arts and Crafts designer Gustave Stickley. Founded in 1891, the company continued in the successful manufacture of moderately-priced home furniture, including the very successful Mission style, until the early 1950s.

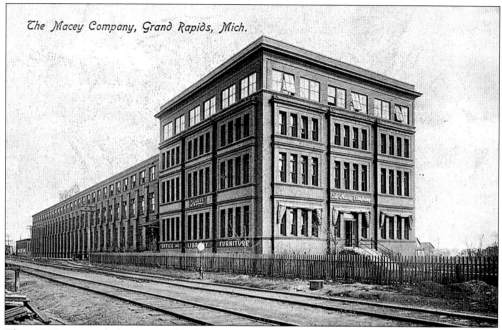

This 1910 postcard showcases the factories of the Fred Macey Company, located on South Division Avenue in the southeast end of the city. This company, founded in 1896, began as a mail-order sales operation, and later went into the successful retail sale of sectional bookcases.

This commercial card, published by the Macey Company about 1910 and sent out by a furniture retailer in Dayton, Ohio, promotes the products of the Macey Company.

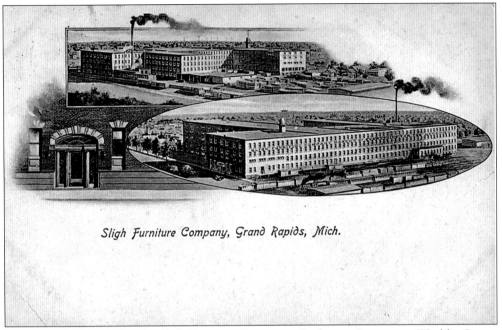

Sligh Furniture Company, Grand Rapids, Mich.

Pictured above in 1925 is the Sligh Furniture Factory on Buchanan Street near Wealthy Street. In the 1920s, this was one of the city's largest furniture manufacturers, employing more than 800 people. This company, started in 1880 by Charles R. Sligh Sr., was a manufacturer of high-quality bedroom furniture through its entire history. It closed in 193, after the death of its founder.

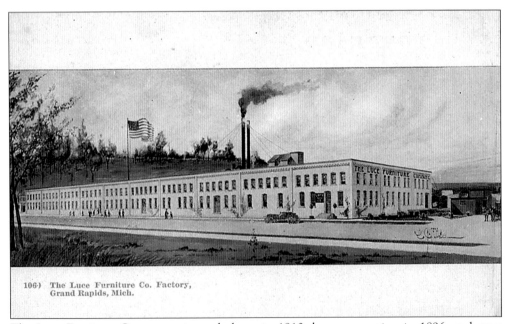

106-) The Luce Furniture Co. Factory, Grand Rapids, Mich.

The Luce Furniture Company, pictured above in 1910, began operation in 1896, and grew steadily in the next three decades; it was ultimately acquired by the Kroehler Company in 1930. It closed during the Great Depression.

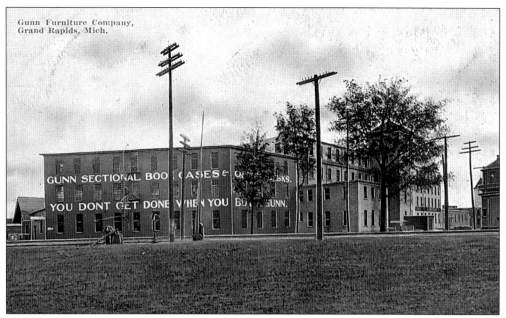

The factory of the Gunn Furniture Company was located on Ann Street in northwest Grand Rapids, as shown in this 1909 postcard. Gunn was a successful manufacturer of sectional bookcases for office and home. After surviving the Depression, it merged with the Bergsma Brothers Company.

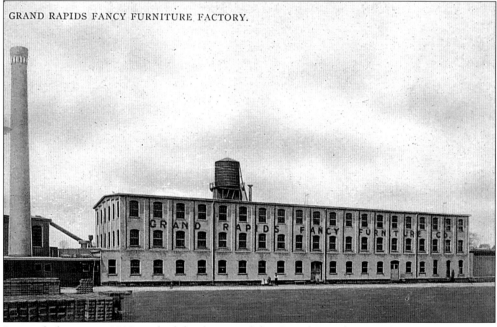

Pictured above is a 1908 card of the factory of the Grand Rapids Fancy Furniture Company, located on Hall Street in southeast Grand Rapids. This company opened in 1898, and successfully manufactured household furniture, including a line of Mission-style furniture. It continued in operation until 1939, when it was acquired by the Steelcase Corporation.

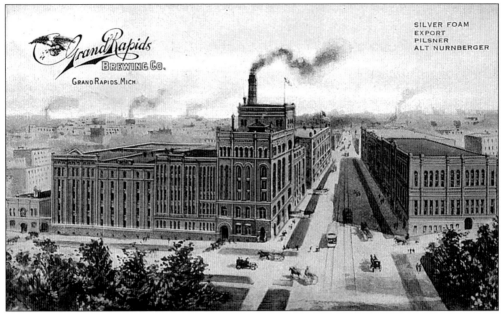

This idealized view of the Grand Rapids Brewing Company was created around 1910. The building was located at the corner of Ionia Avenue and Michigan Street, on the hill east of downtown. Grand Rapids Brewing was incorporated in 1892, and operated (with an interruption for Prohibition) until 1936, when it became part of the Michigan Brewing Company. Later, this building was home to the Fox Brewing Company between 1941 and 1951, and it was razed in 1966. The site is now occupied by the State of Michigan Building.

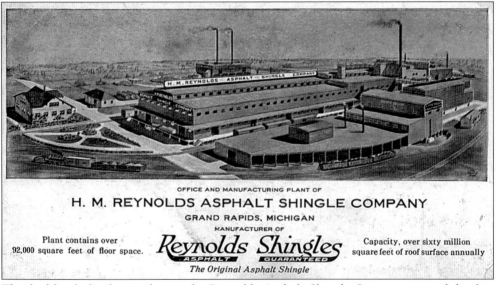

This highly idealized view depicts the Reynolds Asphalt Shingle Company, one of the first manufacturers of "fire-proof" shingles in the United States. The postcard dates from 1915.

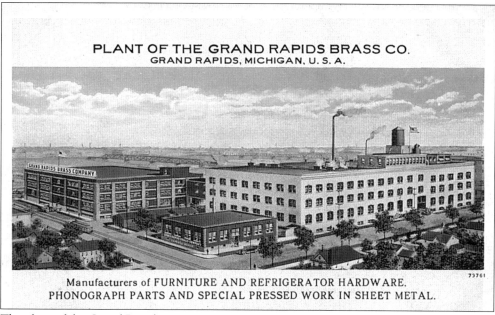

PLANT OF THE GRAND RAPIDS BRASS CO.
GRAND RAPIDS, MICHIGAN, U. S. A.

Manufacturers of FURNITURE AND REFRIGERATOR HARDWARE.
PHONOGRAPH PARTS AND SPECIAL PRESSED WORK IN SHEET METAL.

The plant of the Grand Rapids Brass Company, supplier of brass hardware to the local furniture industry, is shown here in 1925.

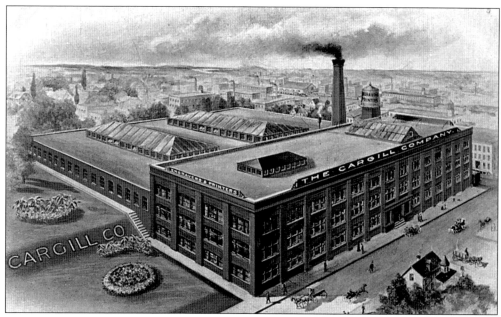

The printing plant of the Cargill Company, printers and engravers, is pictured here around 1910 at its location at Wealthy Street and Commerce Avenue, south of downtown. One of the largest printing/engraving companies in the country at this time, Cargill published complete lines of furniture catalogues and related materials, as well as postcards of local scenes, such as this one.

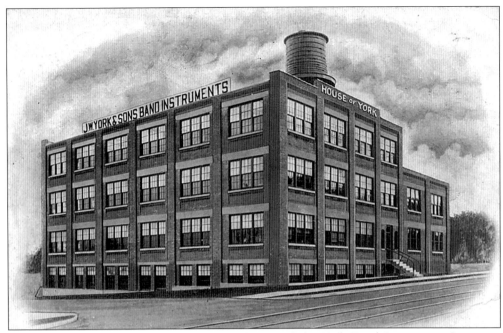

Shown above in this 1909 postcard is the factory of the York Band Instrument Company, located on Division Avenue south of Hall Street. This firm began as J.W. York and Son in 1882, and continued to produce much sought after brass musical instruments for many years.

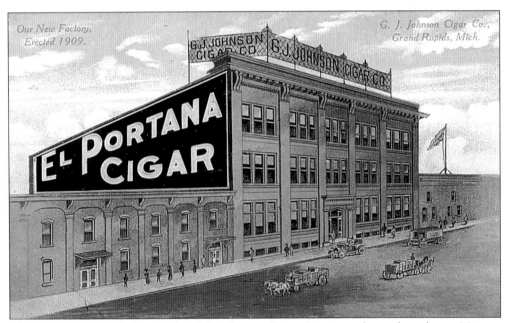

This view from 1909 depicts the G.J. Johnson Cigar Company, located on lower Monroe Avenue (formerly Canal Street). The Johnson Company was a large and important cigar manufacturer, having developed such well-known brands as "Van Dam," and "Dutch Masters." The company was ultimately acquired by the Consolidated Cigar Corporation.

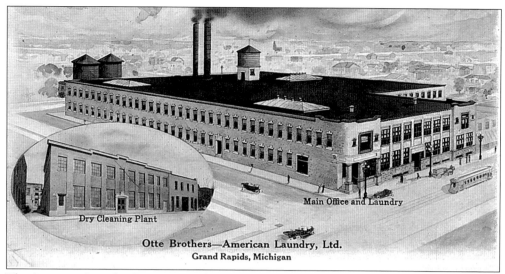

Otte Brothers—American Laundry, Ltd.
Grand Rapids, Michigan

Dry Cleaning Plant

Main Office and Laundry

The American Laundry Company was located on Division Avenue in this 1910 photograph. This building was later replaced by a larger facility on the same site; it was demolished in 1995.

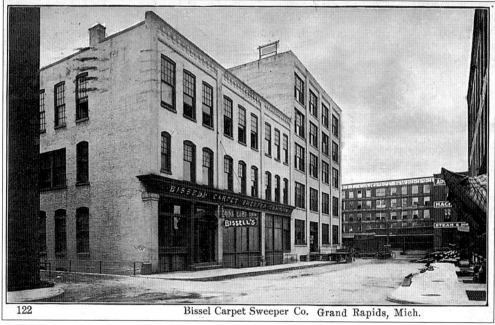

122 Bissel Carpet Sweeper Co. Grand Rapids, Mich.

A 1909 view of the factories of the Bissell Carpet Sweeper Company, located on the east bank of the Grand River, shows the place where DeVos Hall now stands. The company was started by Melville R. Bissell in 1876, in response to the success of a sweeper of his own invention. He initially created the machine to clean up the dust, to which he was acutely allergic, in his crockery shop on Monroe Avenue. The company expanded and was managed to great success by Bissell and his wife, Anna, until Melville's death. Anna took over the operation entirely as the first, and for many years, the only, local female industrialist. Bissell moved to larger quarters in Walker in 1959, and these original factories were razed for the construction of the old Hall of Justice. The site is now occupied by the DeVos Convention Center.

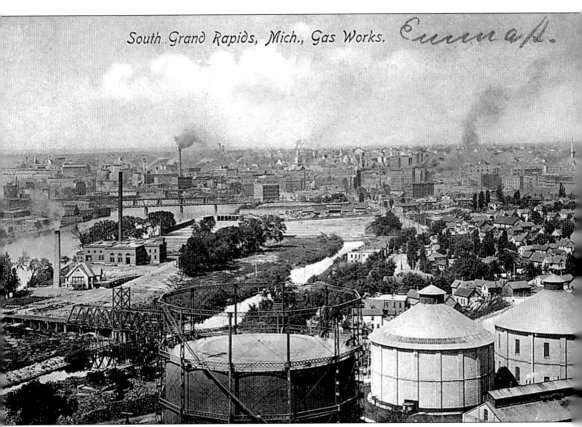

South Grand Rapids, Mich., Gas Works. *Emma A.*

This 1905 view looks northwest across the city. In the foreground are the storage tanks of the local gas company. At center left is the City Power and Garbage Burning facility, located on an island, since merged with the east bank.

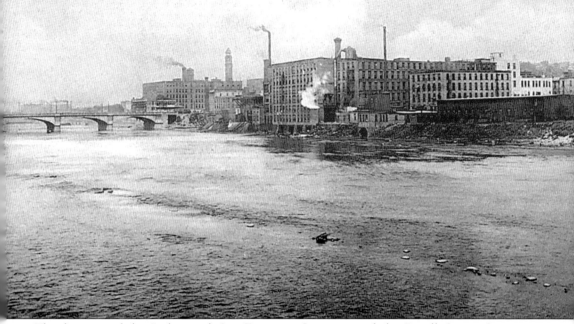

Berkey & Gay, Bissel Carpet Sweeper Co., Grand Rapids, Mich.

The factories of the Berkey and Gay Furniture Company and the Bissell Carpet Sweeper Company, are seen in this 1902 view looking northeast across the Grand River. These two companies were two of the giant manufacturers of their day, and employed thousands of workers. The bridge at the left is the Bridge (Michigan) Street Bridge. A very close look at the center of the picture will show the Grand Trunk Railroad Station under construction.

ACKNOWLEDGMENTS

No major project can be accomplished without the help and encouragement of others, and this book has been no exception.

I am grateful for the counsel and advice of my friends and fellow postcard collectors, Milt Ehlert and Ron Carowicz. I am also most grateful for the help and comments of my brother-in-law, Paul J. LaPorte. His review of the text provided me with many valuable insights and suggestions.

Last, but foremost, I am grateful to my wife, Debbie, and my daughter, Sarah, both of whom have supported and encouraged me during this entire project, and have patiently endured, without snickering, my many comments and lectures on local history. I could not have done this without them.

BIBLIOGRAPHY

In addition to the postcards themselves, including their postal cancellations and messages, a number of sources were consulted to date or more fully caption the images reproduced in this book. Some of these works are common, and some are rare, but nearly all of them can be found in the excellent local history section of the Grand Rapids Public Library. Sources include:

Bak, Richard. *Detroit, A Postcard History*. Chicago: Arcadia Publishing, 1998.

Baxter, Albert. *The History of Grand Rapids, Michigan*. Munsell and Company, 1891.

Bratt, James D. and Christopher H. Meehan. *Gathered at the River: Grand Rapids, Michigan and Its People of Faith*. William B. Eerdmans, 1993.

Carron, Christian G. *Grand Rapids Furniture*. The Public Museum of Grand Rapids, 1998.

Etten, William J. *A Citizens' History of Grand Rapids, Michigan*. A.P. Johnson Company, 1926.

Fisher, Ernest B. *Grand Rapids and Kent County, Michigan, Vol. I & II*. Robert O. Law Company, 1918.

Fitch, George E. *Old Grand Rapids*. 1925.

Lydens, Z.Z., Ed. *The Story of Grand Rapids*. Kregel Publications, 1966.

Mapes, Lynn G. and Anthony Travis. *Pictorial History of Grand Rapids*. Kregel Publications, 1976.

Smith, Jack H. *Postcard Companion*. Wallace-Homestead Book Company, 1989.

Tuttle, Charles Richard. *History of Grand Rapids*. Tuttle and Cooney, 1874. Reprinted, Black Letter Press, 1974.

VanVulpen, James. *Grand Rapids: Then and Now*. Grand Rapids Historical Commission, 1988.